THE POSTCARD HISTORY SERIES

Baltimore
IN VINTAGE POSTCARDS

THE POSTCARD HISTORY SERIES

Baltimore
IN VINTAGE POSTCARDS

Joe Russell and Kate Shelley

ARCADIA

Published by Arcadia Publishing,
an imprint of Tempus Publishing, Inc.
2 Cumberland Street
Charleston, SC 29401

Printed in Great Britain.

Library of Congress Catalog Card Number: 99-65764

For all general information contact Arcadia Publishing at:
Telephone 843-853-2070
Fax 843-853-0044
E-Mail arcadia@charleston.net

For customer service and orders:
Toll-Free 1-888-313-BOOK

Visit us on the internet at http://www.arcadiaimages.com

This book is dedicated to the many volunteers, donors, workers, and participants involved with the Marrow Foundation. Without their efforts, the mother of one of the authors would not be alive today.

CONTENTS

ACKNOWLEDGMENTS

We would like to acknowledge Bill and Mary Martin for the use of their postcards and endless hours of effort on their part. Most of this collection had never been seen prior to the publication of this book. We also thank our parents for their love, support, and guidance.

All proceeds generated from the publication of this book will be donated to the Joey Russell Kate Shelley Friends for Life Fund for Patience assistance.

INTRODUCTION

Through the years, Baltimore's illustrious history has been documented on picture postcards. Using the extensive private collection of Mary and Bill Martin (Joe's grandparents), both of whom were born and raised in Baltimore, this book provides a visual look at historic Baltimore. Their collection is a 30-year accumulation from travels all over the world, consisting of over 100,000 cards, 10,000 of which feature Baltimore.

At the turn of the century there was no telephone, television, internet, or other means of communication that we enjoy today. Picture postcards were the medium by which people reported events, conveyed to others their love of their city, and generally allowed others to share in the beauty and splendor that was Baltimore.

The majority of the cards were printed between the years of 1900 to 1920. These beautiful works of art were sold to the general public at a price of a penny and then mailed for a penny, hence the name penny postcards. The height of production for penny postcards was from 1908 to 1910. Due to their superior printing capability, nearly all picture postcards were printed in Europe, and millions of cards a year were imported into the United States during this era. Photographers took pictures of places and events that took place in Baltimore and then mailed the images to Europe for production. With the onset of World War I, the transportation of pictures to Europe was restricted, thus creating an opportunity for American postcard manufacturers. With inferior printing techniques and equipment, however, the U.S. companies were not able to equal European quality, and desirability of postcards waned.

This book will explore many interesting and important events and traditions in Baltimore's history, such as the fire of 1904, which set many precedents in fire department regulations, and the fishing, crabbing, and oystering industry that has been a focal point of the east coast's seafood trade for many years. The postcards show how the city was alive and vibrant in its past, with people bustling through markets on Broadway and Lexington, gathering their daily staples. Images also depict residents enjoying the many amusements the city had to offer, including Bay Shore Park and Electric Park, among others. Excursion steamers transported vacationers to and from Betterton and Tolchester beaches for summertime fun, while locals and tourists alike enjoyed the culinary delights from a host of fine restaurants throughout town.

Through postcards, we will transport you back to the early 1900s, recreating the many times, places, and events that have shaped and created what we know today as the city of Baltimore. The creation of this book has allowed us, the authors, to fall in love with our city, and we hope that you will too. Welcome to Charm City!

One
TOUR OF THE CITY STREETS

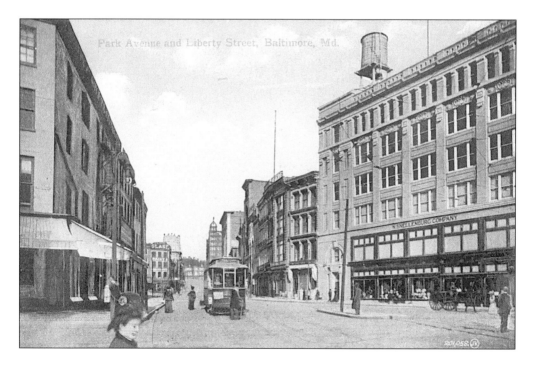

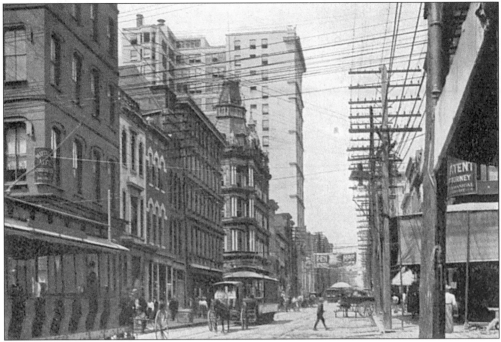

BALTIMORE STREET, BEFORE THE FIRE. In this view taken before 1904, streetcars, pedestrians, and horse carriages jockey for position.

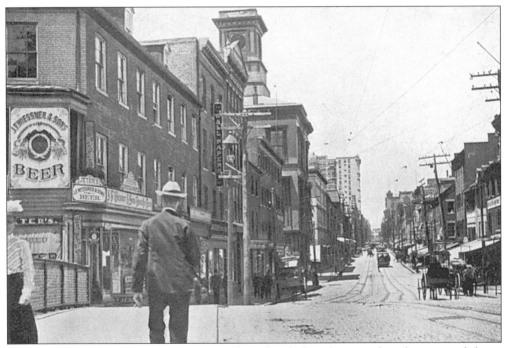

BALTIMORE STREET, FROM THE BRIDGE. Also taken before the great fire, this postcard shows J.F. Weissner and Sons Beer standing prominently on the corner.

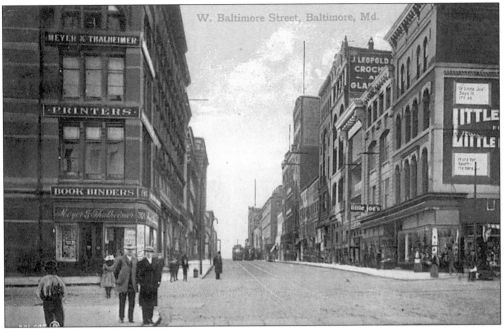

BALTIMORE STREET IN 1909. Meyer & Thalheimer's Printing and Bookbinding thrives in downtown.

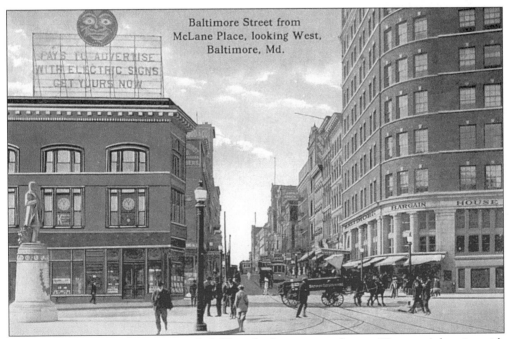

BALTIMORE STREET, 1910. An early billboard advertisement boasts, "Pays to Advertise with Electric Signs."

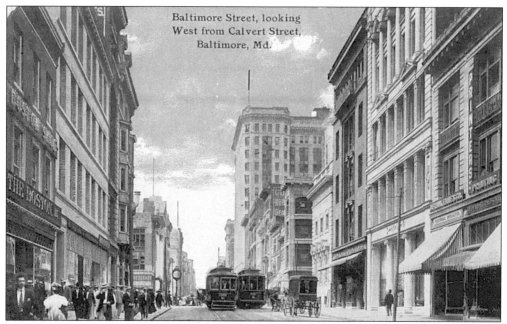

Baltimore Street, looking
West from Calvert Street,
Baltimore, Md.

VIEW OF BALTIMORE STREET FROM CALVERT STREET, 1910. The Boston Shoe Company stands amidst Baltimore's heavy foot traffic.

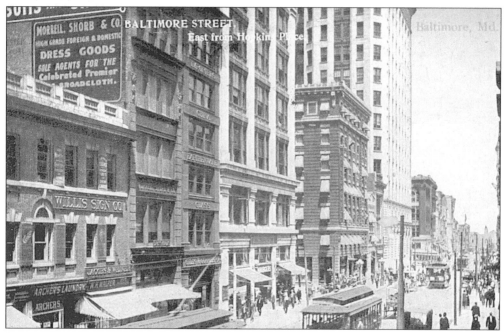

MORRELL, SHORB & CO.
HIGH GRADE FOREIGN & DOMESTIC
DRESS GOODS
SOLE AGENTS FOR THE
Celebrated Premier
BROADCLOTH.

BALTIMORE STREET,
East from Hopkins Place

Baltimore, Md.

WILLIS SIGN CO.

ARCHERS LAUNDRY

ARCHERS

VIEW OF BALTIMORE STREET FROM HOPKINS PLACE. Streetcars dominate the avenue, which is lined with Willis Sign Company and Archer's Laundry.

12

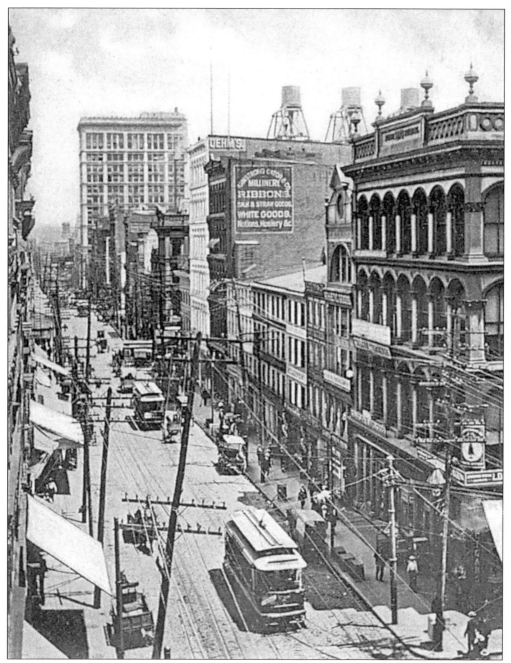

EARLY BALTIMORE STREET. Neighborhood businesses battle the hot summer sun with ray-blocking awnings.

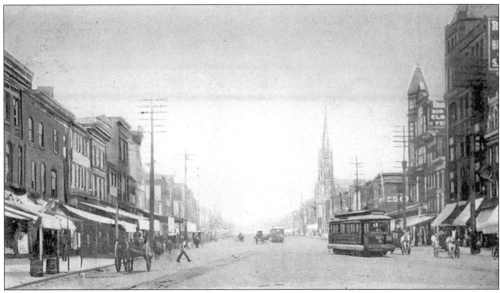

LOWER BROADWAY IN 1907. Shops are open and ready for business.

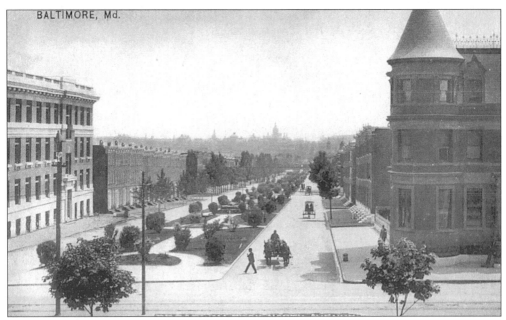

RESIDENTIAL SECTION OF BROADWAY. A Victorian townhome overlooks the Baltimore skyline.

J.W. PUTTS COMPANY. Notice their American Flag flying high above Lexington Street.

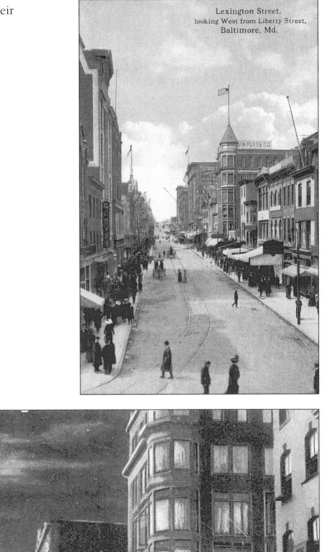

Lexington Street, looking West from Liberty Street, Baltimore, Md.

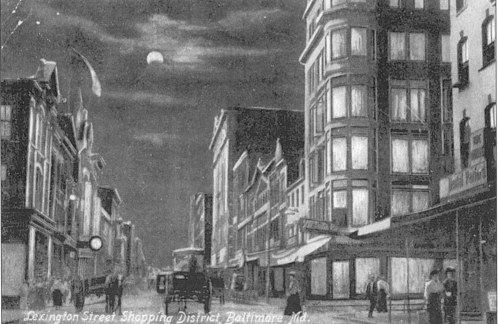

LEXINGTON STREET, 1907. A nighttime view of this shopping district shows streets lit by moonlight.

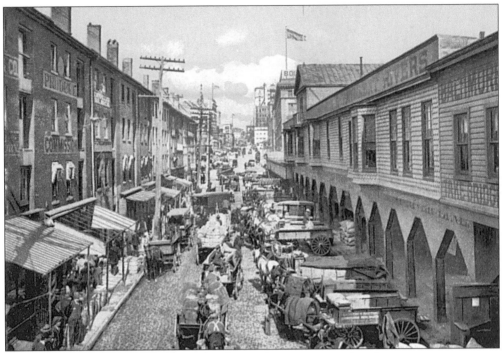

LIGHT STREET, 1906. The streets are bustling with commerce and trade.

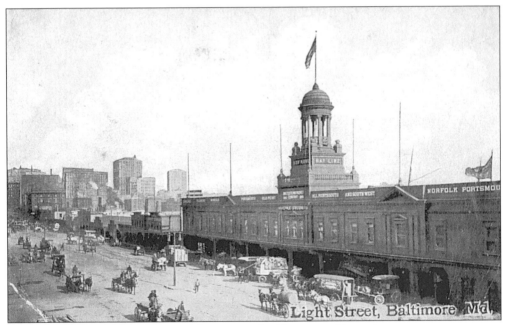

LIGHT STREET. The Bay Line Norfolk Steamers building is visible in this view.

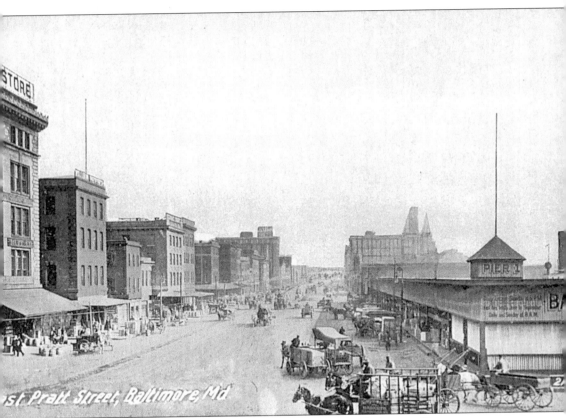

EAST PRATT STREET, C. 1910. Baltimore's Pier One awaits the day's cast off.

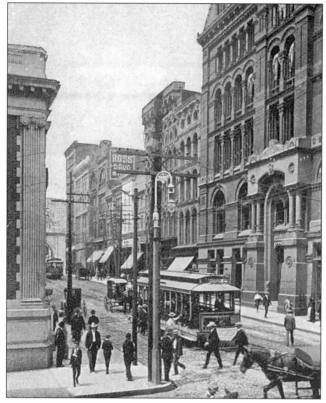

BALTIMORE AND CALVERT STREET, BEFORE THE GREAT FIRE. The Madison Avenue streetcar charges down the road.

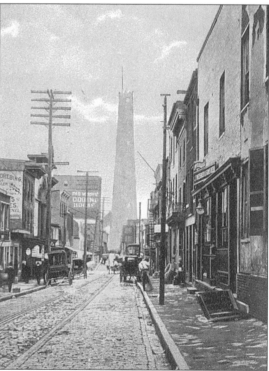

EAST FAYETTE STREET, 1907. Baltimore's famous shot tower stands tall in the distance.

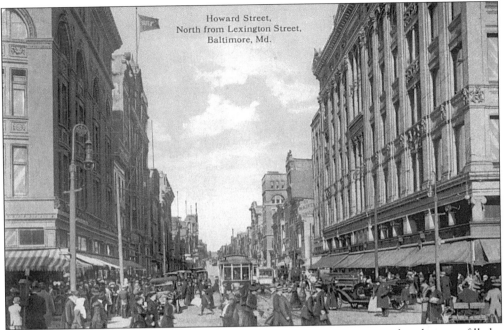

Howard Street,
North from Lexington Street,
Baltimore, Md.

HOWARD STREET. On this busy afternoon, hundreds of Baltimoreans and early autos fill the street.

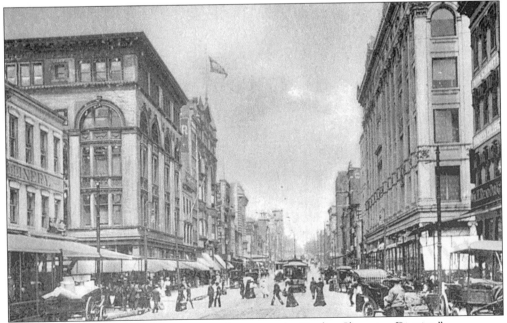

NORTH HOWARD STREET. This area was known as the "Ladies Shopping District."

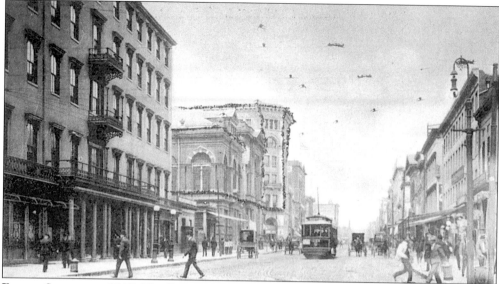

EUTAW STREET, C. 1907. The Eutaw House is featured in this postcard.

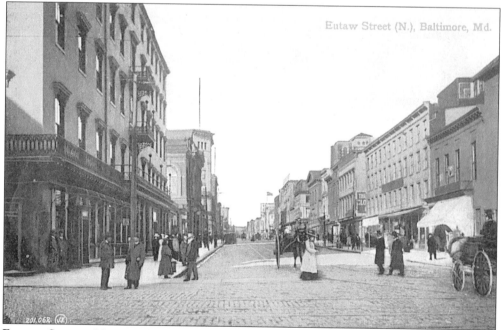

Eutaw Street (N.), Baltimore, Md.

EUTAW STREET NORTH. On this 1913 postcard, A.D.H. writes to Albert Rider, "This is another street we usually walk down, but Lexington and Balto Street are the business streets."

Two

GETTING AROUND,
IN AND OUT OF TOWN

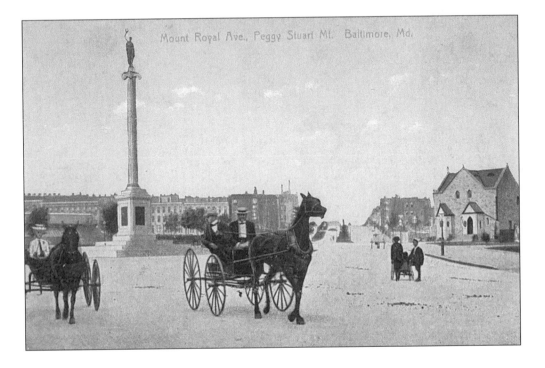

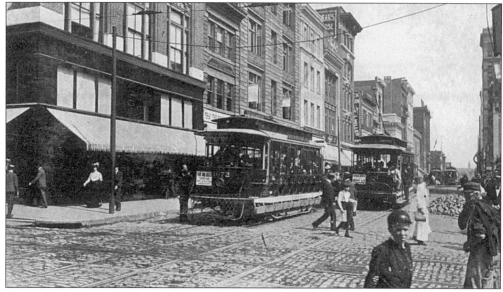

CAR #1472 ON BALTIMORE AND CHARLES STREETS. Streetcars frequently carried Baltimoreans through the city.

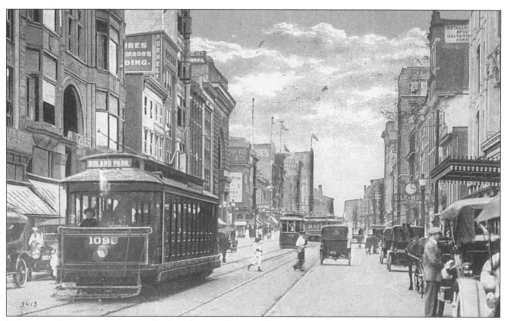

HOWARD STREET, 1920. Filled with travelers, Roland Park Car #1095 rolls down a busy street.

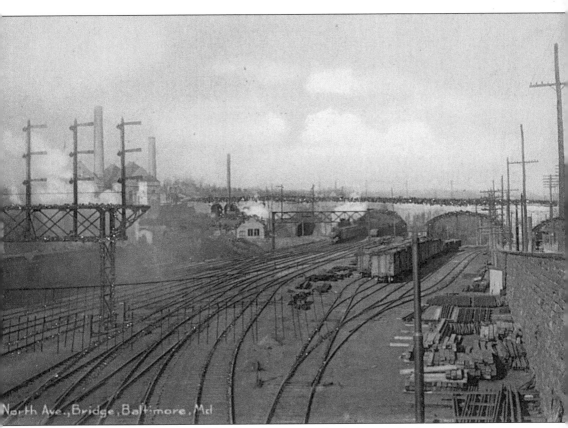

North Ave., Bridge, Baltimore, Md

BALTIMORE FREIGHT TRAINS, C. 1907. Standing at the North Avenue Bridge, these trains rest before their next trip.

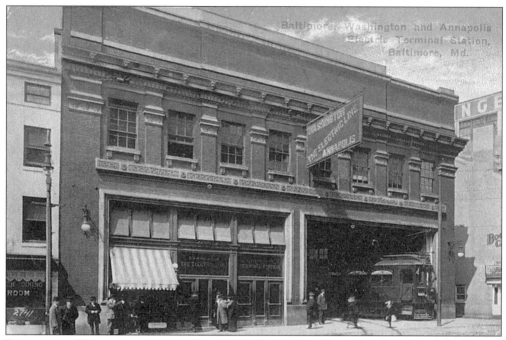

BALTIMORE, WASHINGTON, AND ANNAPOLIS ELECTRIC TERMINAL STATION. This station housed an important Maryland transport system. The photograph was taken in 1915.

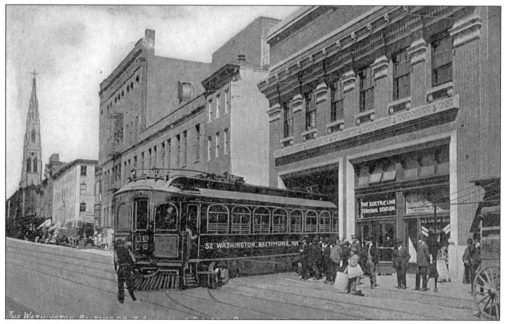

CAR # 52 DEPARTING BALTIMORE, WASHINGTON AND ANNAPOLIS ELECTRIC TERMINAL STATION, 1911. All aboard.

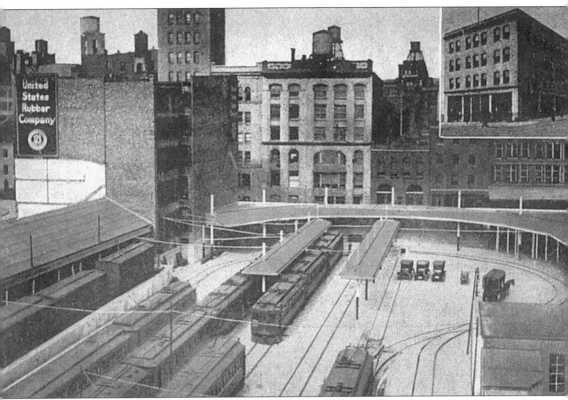

WASHINGTON, BALTIMORE AND ANNAPOLIS TERMINAL. The 1920s brought a new terminal to Baltimore.

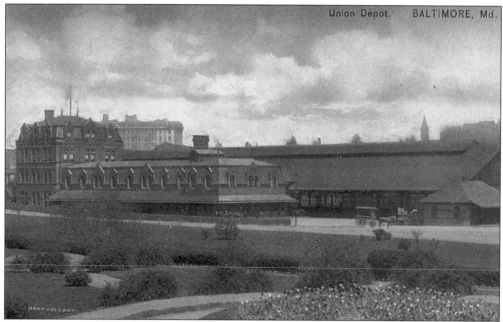

Union Depot. BALTIMORE, Md.

BALTIMORE'S UNION DEPOT, 1910.

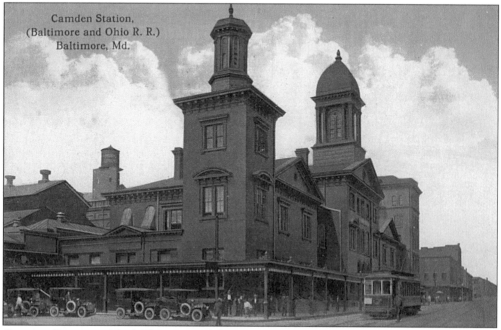

Camden Station,
(Baltimore and Ohio R. R.)
Baltimore, Md.

CAMDEN STATION, 1916. This postcard features an important stop on the Baltimore and Ohio Railroad.

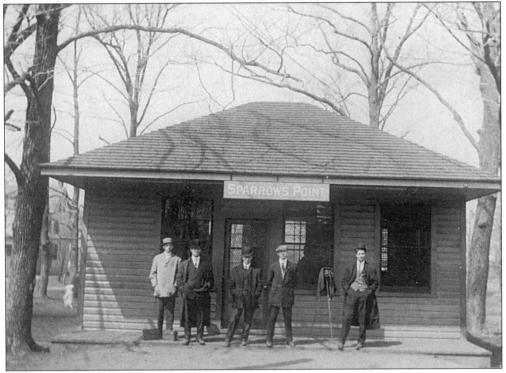

SPARROWS POINT TRAIN STATION. This real photo postcard shows gentlemen waiting with their cameras ready.

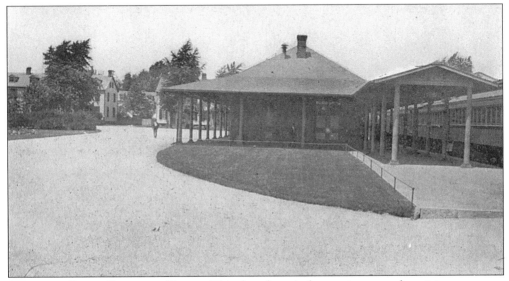

SPARROWS POINT RAILROAD DEPOT. This shot doesn't show quite as much activity.

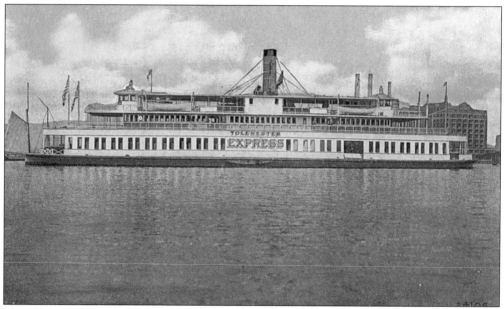

THE *TOLCHESTER EXPRESS*, 1930. Excursion steamers toted city dwellers to Chesapeake summer fun.

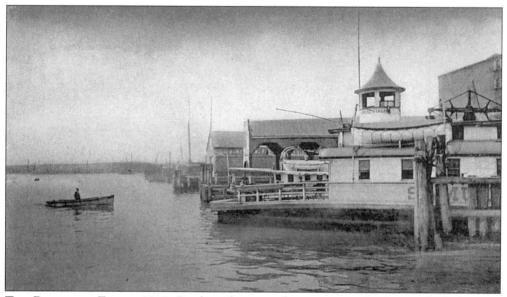

THE *BROADWAY FERRY*, 1910. Ready and waiting for customers, the ferry is docked in this postcard view.

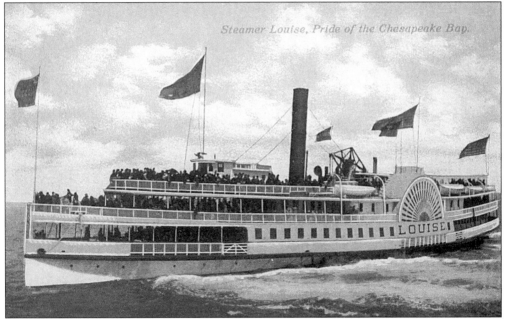

THE STEAMER LOUISE. This vessel claimed to be the "The Pride of the Chesapeake Bay."

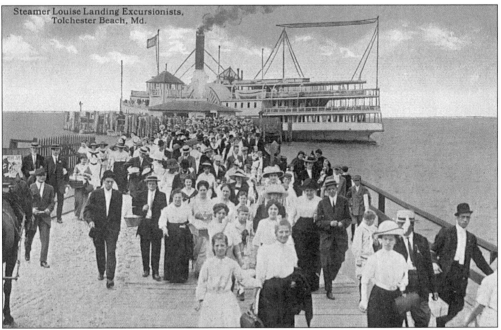

ANOTHER VIEW OF LOUISE. Upon landing at Tolchester Beach, hundreds of travelers pour out to their summer retreat.

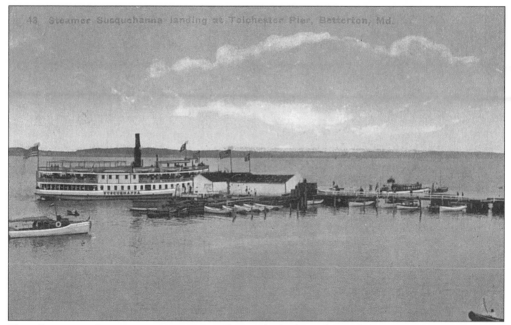

THE STEAMER *SUSQUEHANNA*, 1917. She is docked at the Tolchester Pier in Betterton, another haven for summer fun for Baltimore residents.

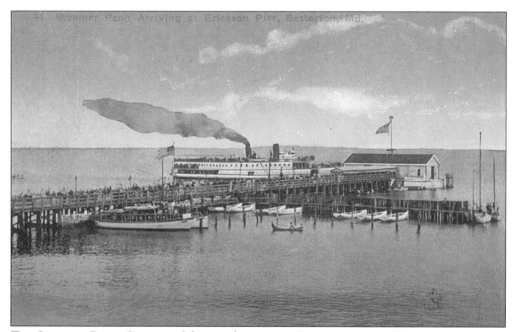

THE STEAMER *PENN*. Step out of the way, here comes *Penn* on its way to Betterton again.

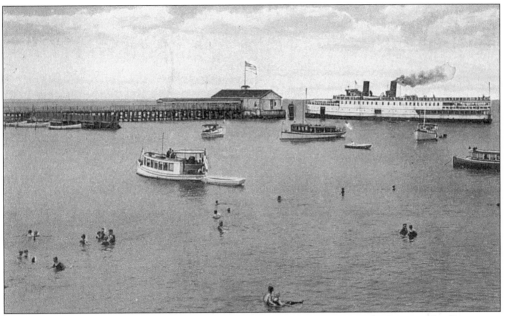

BETTERTON HARBOR. Still thriving in the 1920s, a steamer awaits docking at the Betterton Harbor.

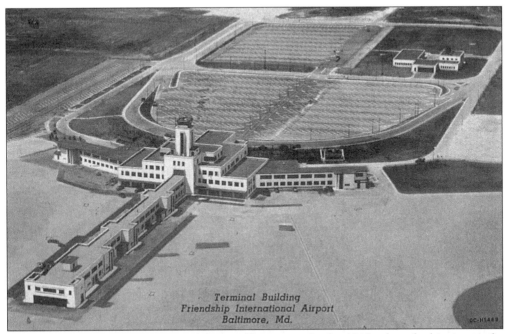

Terminal Building
Friendship International Airport
Baltimore, Md.

AERIAL VIEW OF THE BALTIMORE AIRPORT TERMINAL. In the 1940s, those looking to get far away exited through Friendship International Airport.

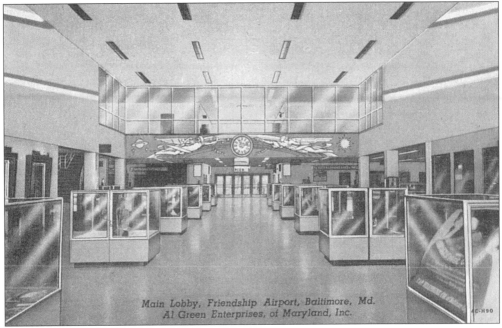

Main Lobby, Friendship Airport, Baltimore, Md.
Al Green Enterprises, of Maryland, Inc.

FRIENDSHIP AIRPORT'S MAIN LOBBY, C. 1940S.

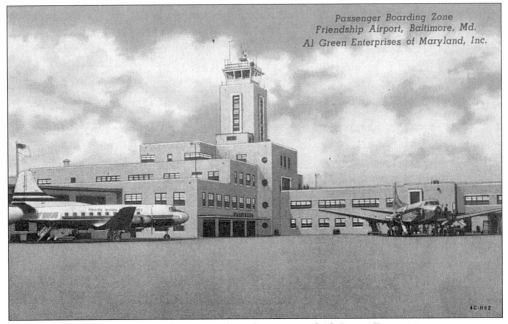

Passenger Boarding Zone
Friendship Airport, Baltimore, Md.
Al Green Enterprises of Maryland, Inc.

PASSENGER BOARDING ZONE. Passengers board courtesy of Al Green Enterprises.

Three

SHOP 'TIL YOU DROP

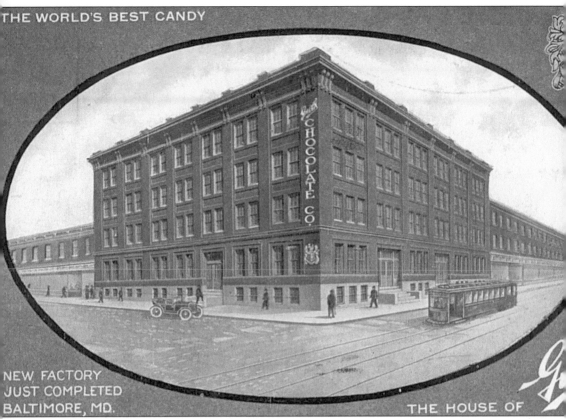

GUTH CANDY AGENCY'S NEW FACTORY, 1911. This company staked their claim for the world's best candy.

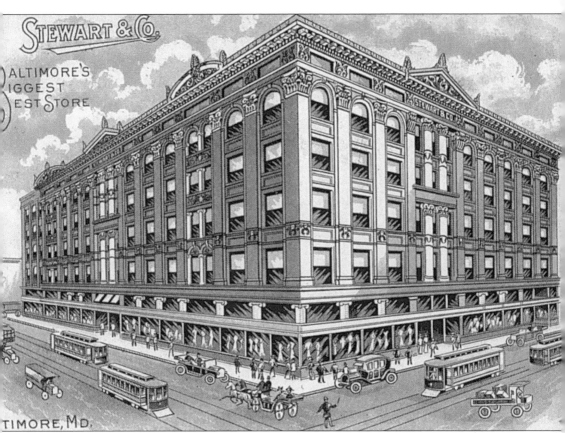

STEWART AND COMPANY STORE. This advertising postcard brags that they are Baltimore's biggest and best store.

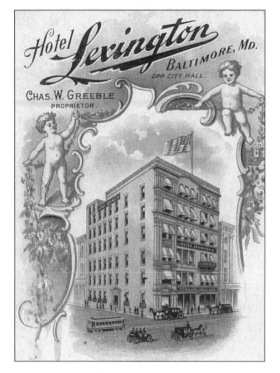

THE HOTEL LEXINGTON, 1907. Owned by Charles W. Greeble, this hotel stands among the many great shops.

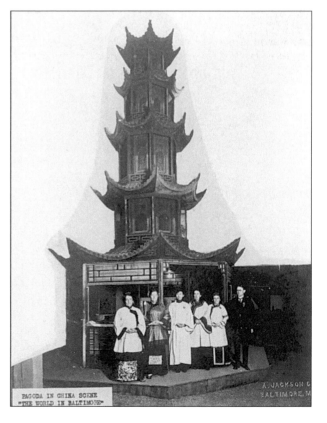

SHOPPING DISTRICT RESTAURANT. "The World in Baltimore," as shown with this Chinese Pagoda, proves to be an interesting diversion.

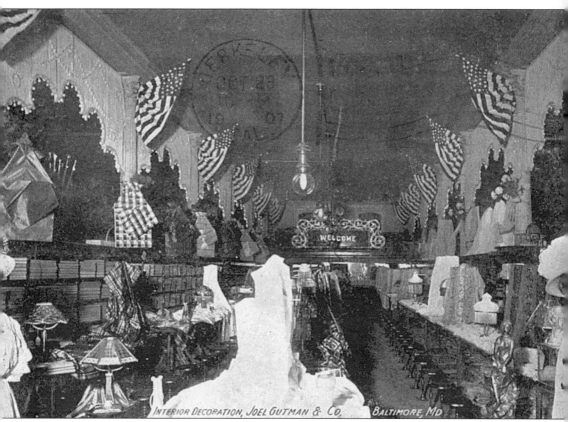

INTERIOR OF THE DECORATION DEPARTMENT, 1907. This shot was provided by the Joel Gutman & Company Interior Decoration Department.

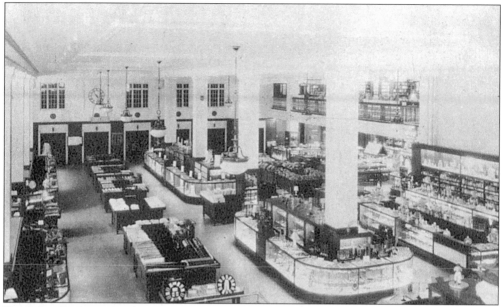

THE MAY COMPANY'S MAIN FLOOR. This image was taken before shop hours.

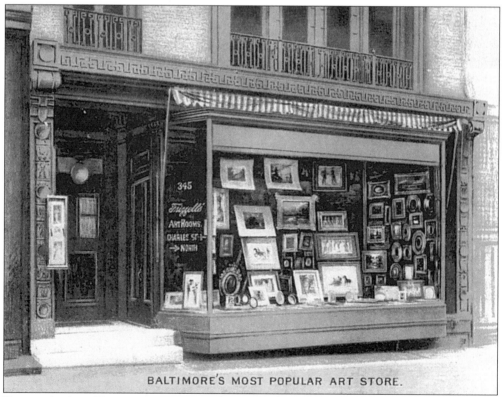

BALTIMORE'S MOST POPULAR ART STORE.

FRIZZELL'S ART ROOMS, 1907. Located on Charles Street, Frizzell's was Baltimore's most popular art store.

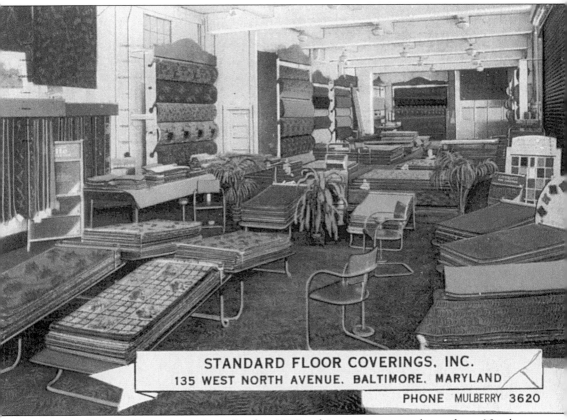

STANDARD FLOOR COVERINGS, INC.
135 WEST NORTH AVENUE, BALTIMORE, MARYLAND
PHONE MULBERRY 3620

STANDARD FLOOR COVERINGS, INC. In the 1940s, this company was located on North Avenue. They invited shoppers to come in and "bring quality and color harmony to the floor in your home."

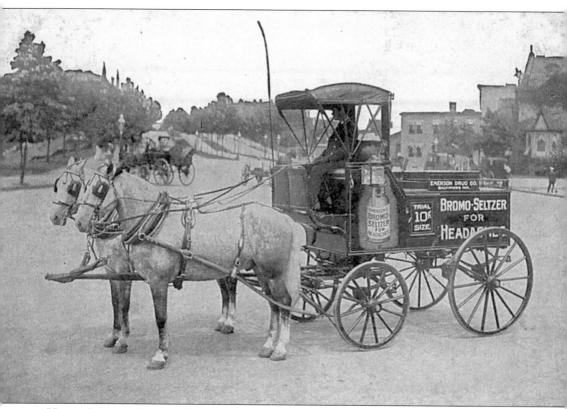

HORSE-DRAWN WAGON. The Emerson Drug Company advertises Bromo-Seltzer for headaches for 10¢ for a trial size.

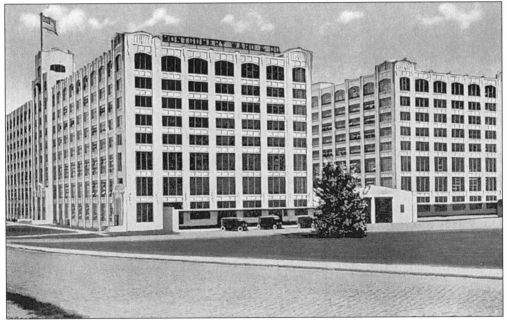

MONTGOMERY WARDS COMPANY BUILDING, 1920S. The Montgomery Wards Company employed many people from Baltimore, including my grandparents (Joe Russell), who met there in the 1960s.

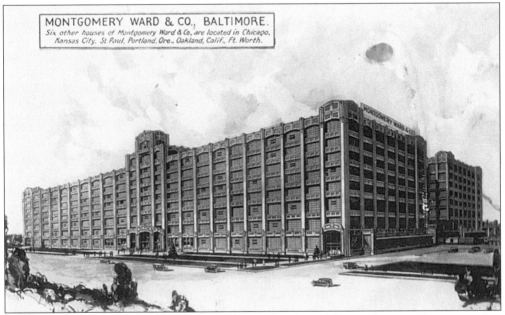

ANOTHER VIEW OF MONTGOMERY WARDS. Another shot of the catalog giant boasts its other houses in Chicago, Kansas City, St. Paul, Portland, Oakland, and Fort Worth.

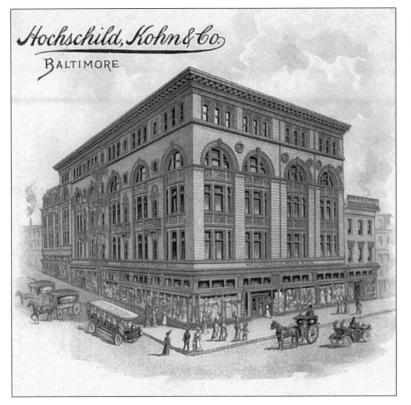

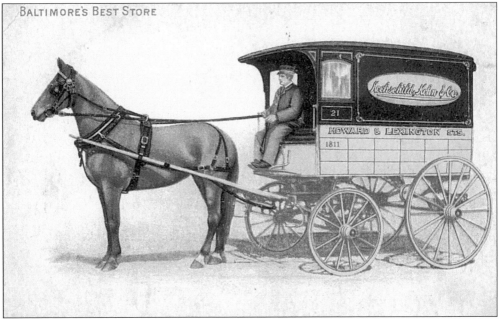

HOCHSCHILD, KOHN, AND COMPANY'S HORSE-DRAWN WAGON. The emblem is from Baltimore's best store, located on Howard and Lexington Streets.

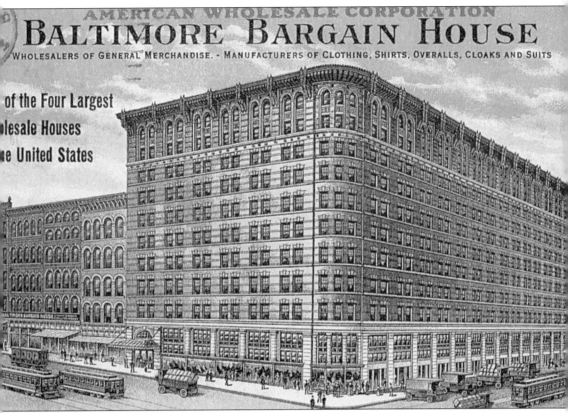

BALTIMORE BARGAIN HOUSE. This American wholesale corporation sells clothing, shirts, overalls, cloaks, and suits.

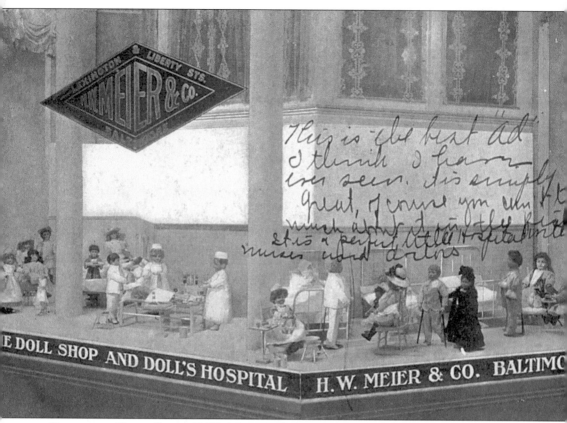

BALTIMORE DOLL SHOP. H.W. Meier and Company provided the Doll Shop and Doll's Hospital on Lexington and Liberty Streets.

Four

A BITE TO EAT

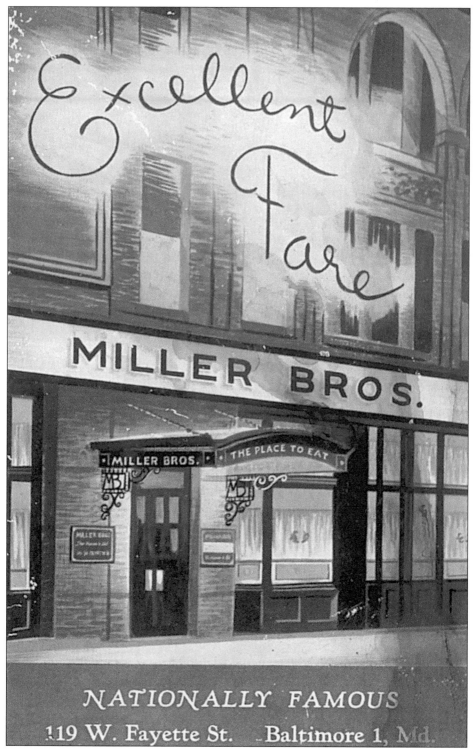

MILLER BROTHERS RESTAURANT. The nationally famous restaurant on Fayette Street claims that their excellent fare—no music, no dancing, no frills—make it *the* place to eat.

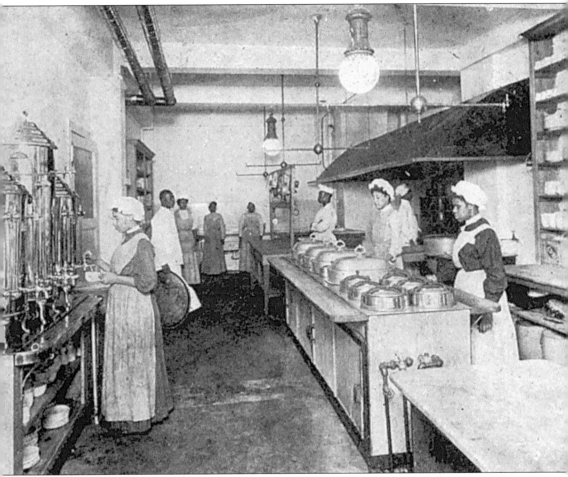

BERNHEIMER BROTHERS. This postcard gives a behind-the-scenes peek at the kitchen.

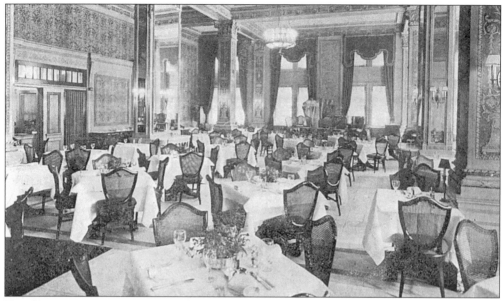

THE SOUTHERN HOTEL. Its main dining room appears warm and inviting.

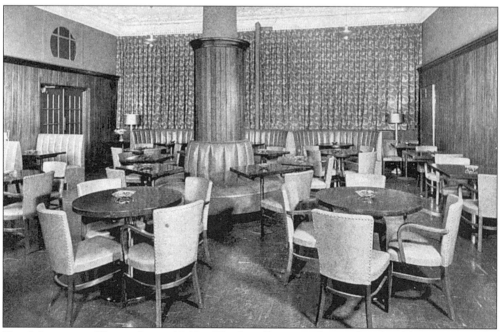

THE MARYLAND HOTEL, LATE 1940s. This hotel's air-conditioned cocktail lounge sat in the heart of downtown Baltimore on Fayette and St. Paul.

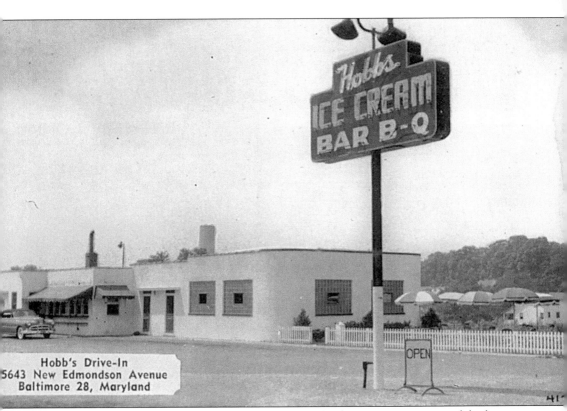

Hobb's Drive-In
5643 New Edmondson Avenue
Baltimore 28, Maryland

EDMONSON AVENUE. This new street featured an early drive-in ice cream and barbeque restaurant named Hobb's Drive-In.

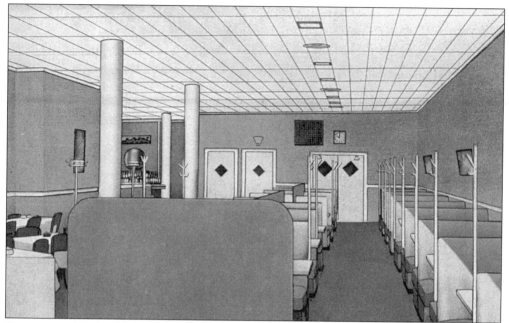

Chungking Restaurant. Located on Fayette Street opposite the Lord Baltimore Hotel, this Chinese-American restaurant featured "the finest in foods and drinks at moderate prices."

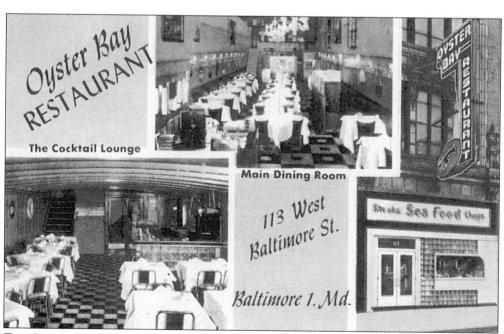

The Oyster Bay Restaurant. Baltimore's famous seafood is featured along with steaks and chops at this restaurant on Baltimore Street.

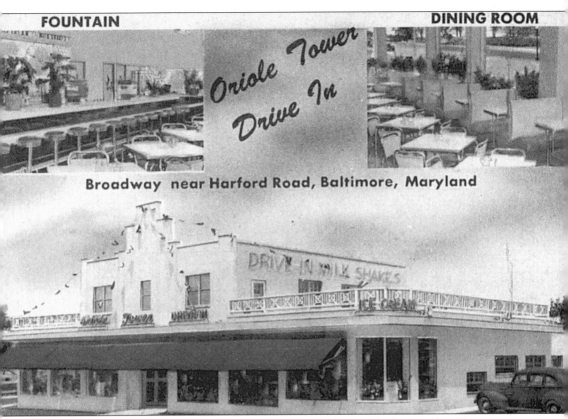

FOUNTAIN

DINING ROOM

Broadway near Harford Road, Baltimore, Maryland

THE ORIOLEE TOWER. Located on Broadway near Harford Road, the Oriolee Tower was another early drive-in restaurant.

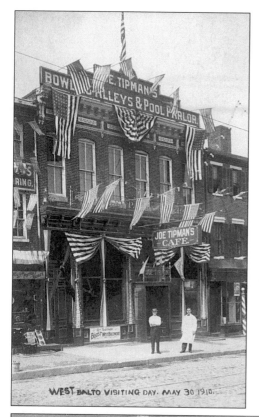

JOE TIPMAN'S BOWLING ALLEY AND POOL PARLOR. In 1910, West Baltimore was the home of the well-known boxer's bowling alley and pool parlor.

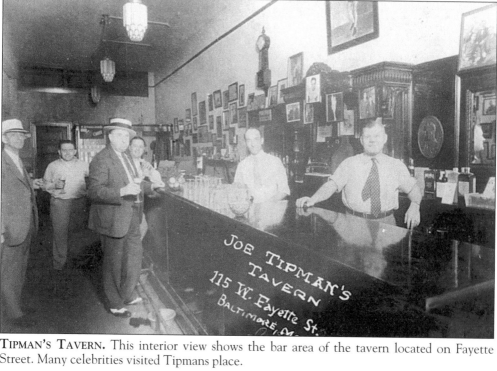

TIPMAN'S TAVERN. This interior view shows the bar area of the tavern located on Fayette Street. Many celebrities visited Tipmans place.

JOE'S NEW CAFE. Joe Tipman and Baron Munchausen stand in front of the cafe, which featured Graupner's Beer on draught.

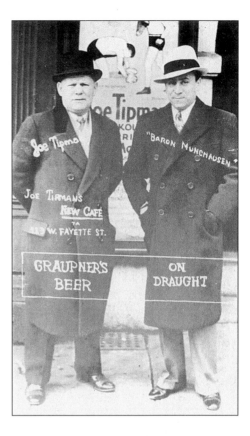

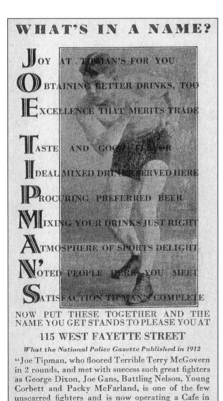

BALTIMORE BOXING. This postcard from 1912 is a testament to Joe Tipman's successes.

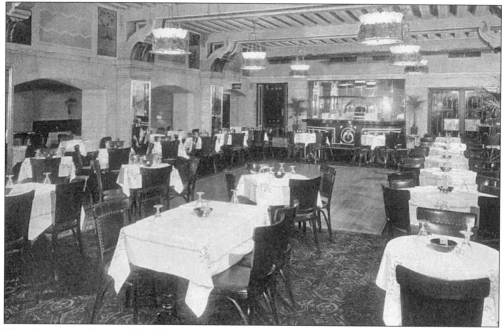

THE EMERSON HOTEL. The Chesapeake Lounge, which offered cocktails and dancing without a cover charge, was located in the Emerson Hotel.

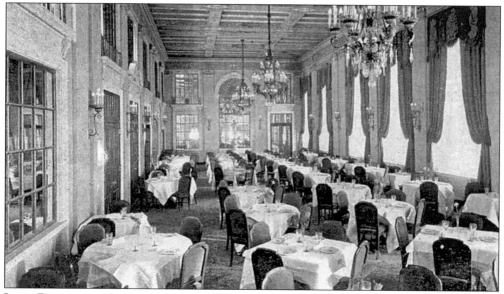

LORD BALTIMORE HOTEL. Sophisticated elegance dominates the hotel's main dining room.

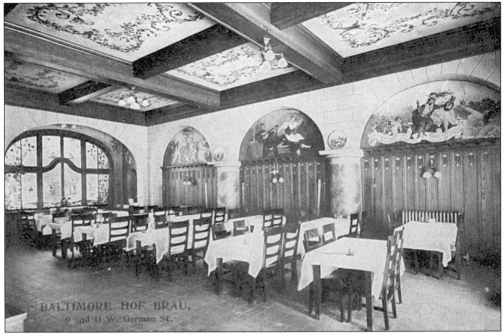

BALTIMORE'S HOF BRAU. Bratwurst and sauerkraut proved to be standard fare at this eatery on German Street.

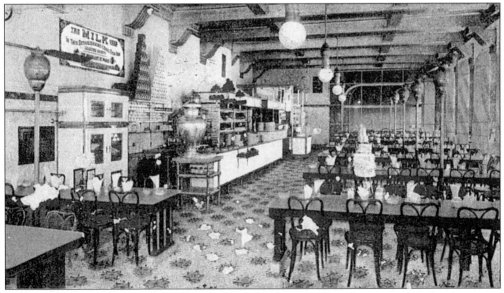

A CHILD'S PLACE, 1908. This postcard shows the dining area with a view of the kitchen.

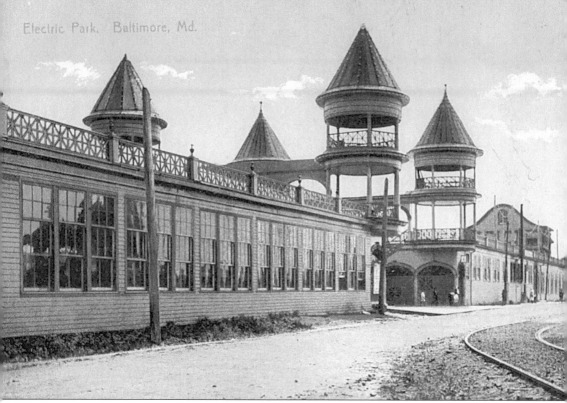

Electric Park, Baltimore, Md.

WALNUT GROVE NIGHT CLUB. In the 1940s, this Hanover Street establishment hosted top bands and variety acts, housing up to 1,200 customers at a time.

Five

WHAT TO DO, WHAT TO DO

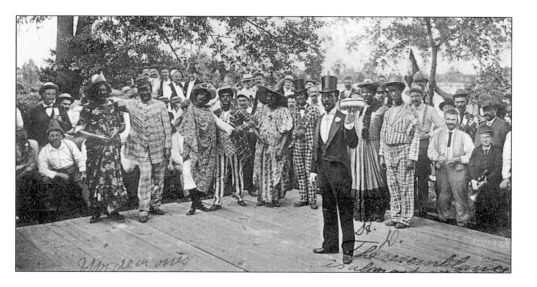

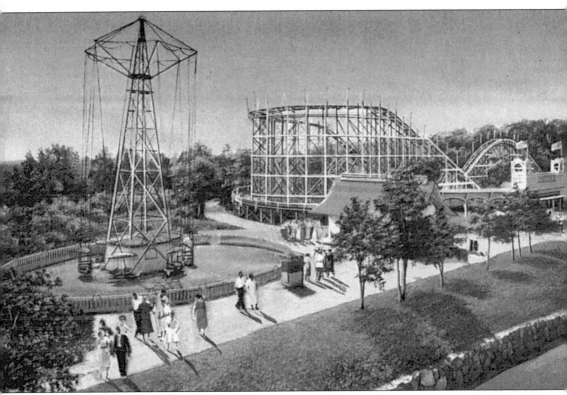

Circus Swing and Roller Coaster, Carlin's Park. This amusement park was a fun diversion for many Baltimore residents.

MARATHON DANCERS. Carlin's Green Palace hosted the International Mad Marathon Dance Competition beginning on May 27, 1931. Good luck to Betty and Rene.

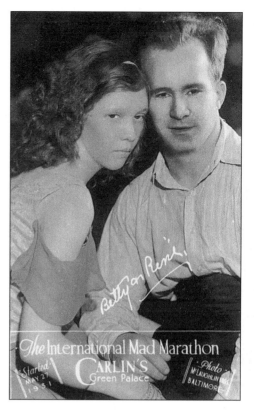

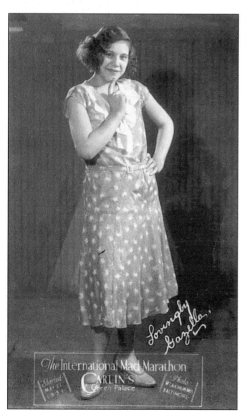

INTERNATIONAL MAD MARATHON. Gazella looks to give it a try at the competition.

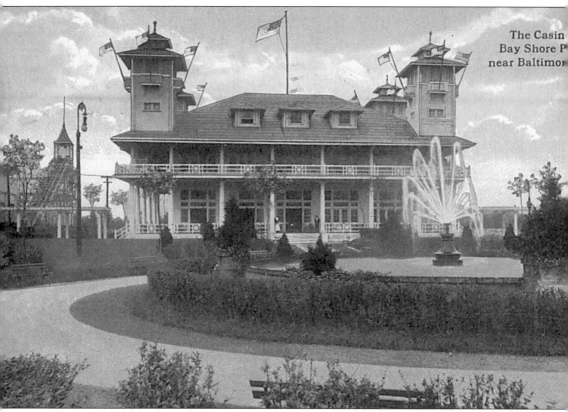

The Casin[o]
Bay Shore P[ark]
near Baltimor[e]

CASINO AT BAY SHORE PARK, 1914. This postcard gives a nice view of the casino's fountain.

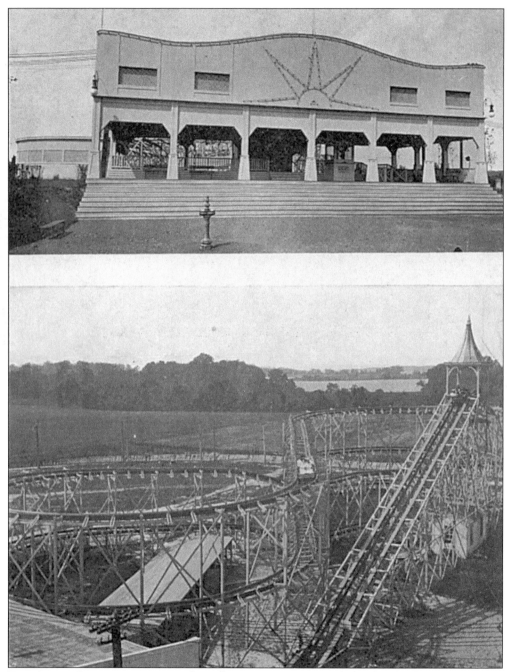

BAY SHORE ROLLER COASTER. The roller coaster entertained the daredevils out for a good time at this amusement park.

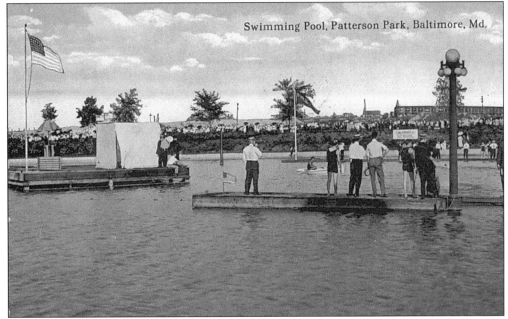

Swimming Pool, Patterson Park, Baltimore, Md.

PATTERSON PARK, 1910. This park had its own swimming pool for refreshment from the hot summer sun.

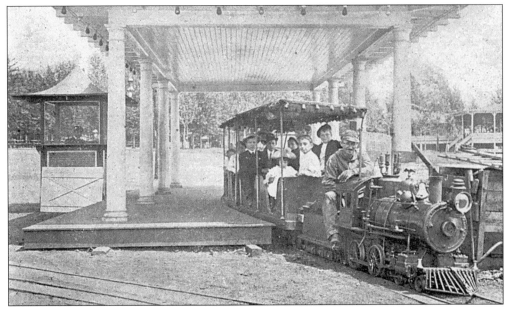

RIVER VIEW PARK. Families enjoyed the miniature railway ride through the park.

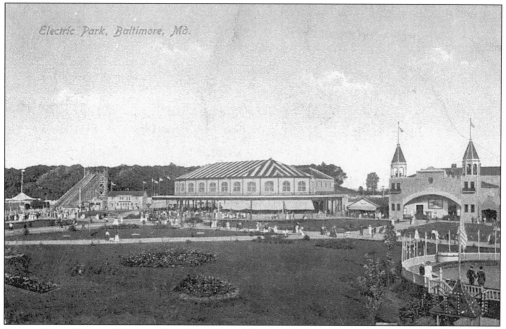

RIVER VIEW PARK. Here is a broader view of this early amusement park, with people strolling from one diversion to another.

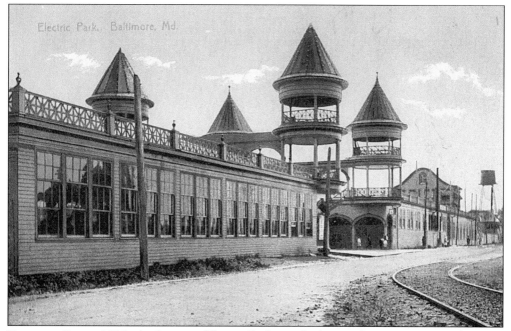

ELECTRIC PARK, 1909. At this time, Electric Park was the home of amusements in Baltimore.

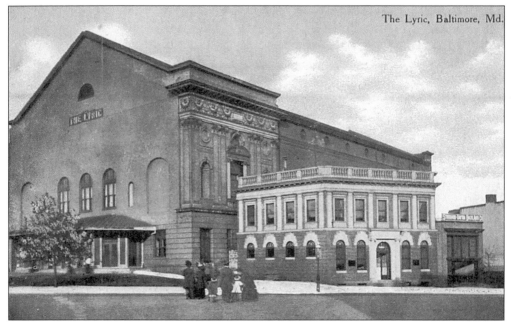

The Lyric, Baltimore, Md.

THE LYRIC OPERA HOUSE, 1908. The opera house was the stage for theatre performance here in Baltimore.

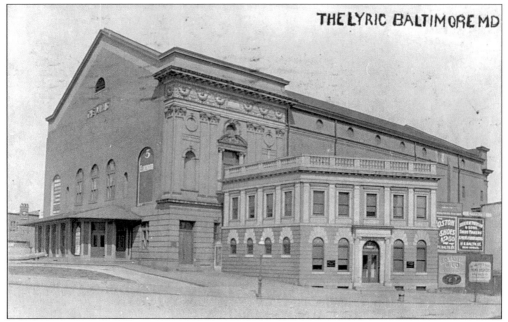

THE LYRIC BALTIMORE MD

REAL PHOTO POSTCARD VIEW OF THE LYRIC.

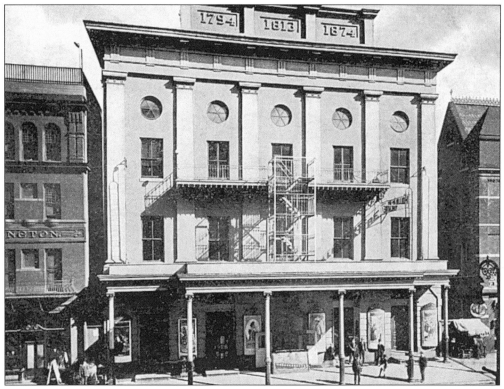

THE HOLIDAY STREET THEATRE, 1907. This was another one of Baltimore's home for the arts.

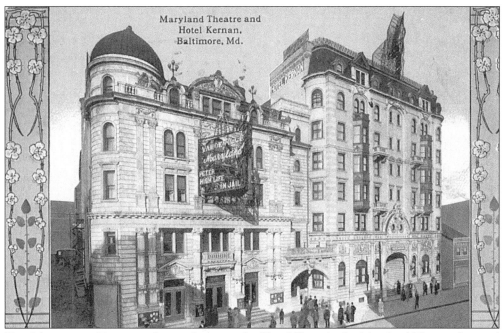

THE MARYLAND THEATRE. Located next to the Hotel Kernan, the Maryland Theatre featured the typical vaudeville acts of the era.

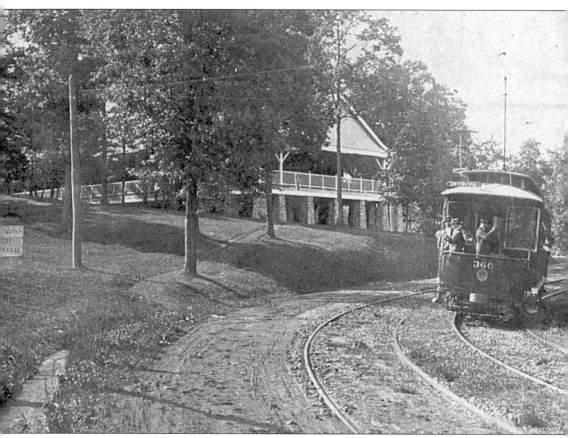

TROLLEY CAR #360. Here, the trolley car makes its way through Gwynn Oak Park.

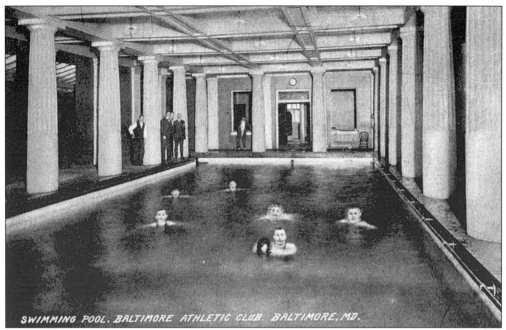

BALTIMORE ATHLETIC CLUB, 1915. Swimmers enjoyed the indoor pool.

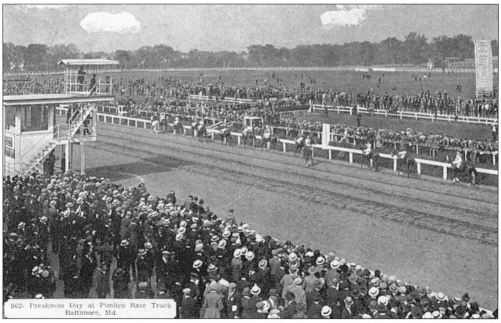

PREAKNESS DAY AT THE PIMLICO RACE TRACK. Baltimore is home of one of the three jewels of today's triple crown of horse racing.

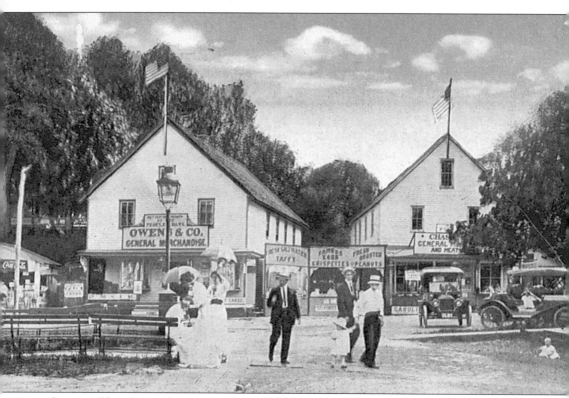

SUMMER HOT SPOT, BETTERTON BEACH. This is a nice shot of the business section featuring Owens and Co. General Store.

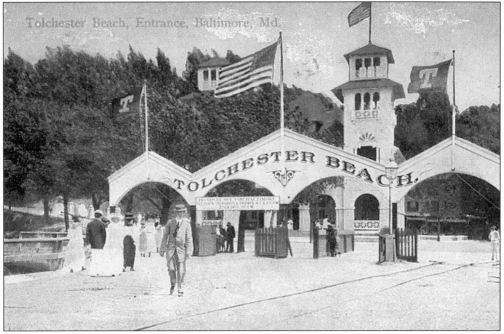

Tolchester Beach, Entrance, Baltimore, Md.

TOLCHESTER BEACH. Race tracks and horses provided thrills a plenty at another one of Baltimore's summer resorts.

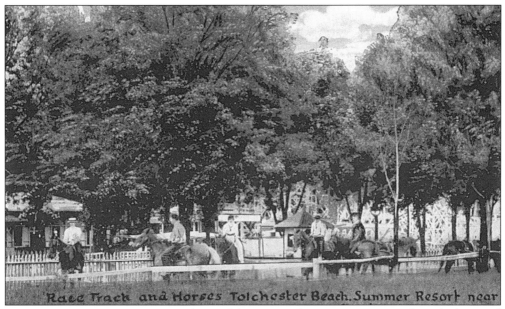

Race Track and Horses Tolchester Beach. Summer Resort near

TOLCHESTER RESORT. Upon arrival to Tolchester Beach, vacationers enter through the grand arches.

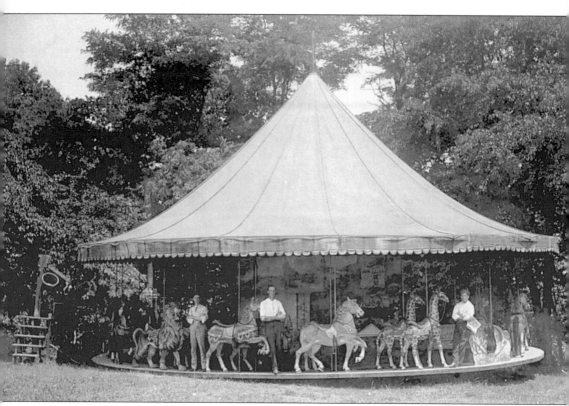

EARLY BALTIMORE CAROUSEL. Selby Studios of Lexington Street captured this fantastic photo.

Six

BALTIMORE'S MARKETS

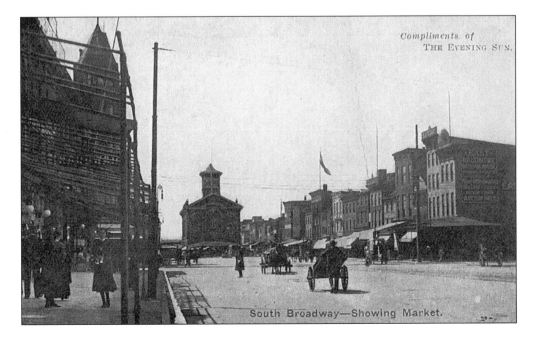

South Broadway—Showing Market.

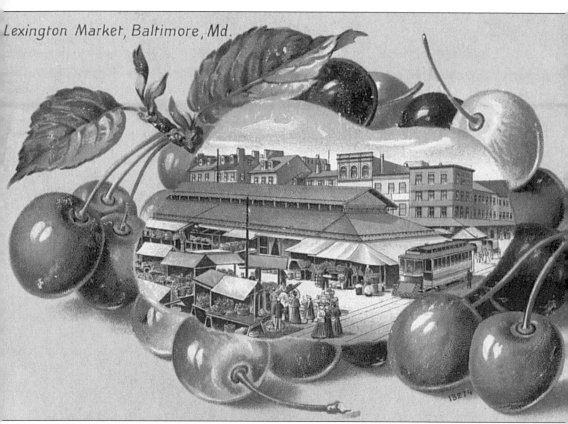

Lexington Market, Baltimore, Md.

An Unusual Postcard From 1915. "This is some market place. . . can't imagine our trade shopping here," remarked Helen and Charlie from Rhode Island on this cherry-bordered postcard.

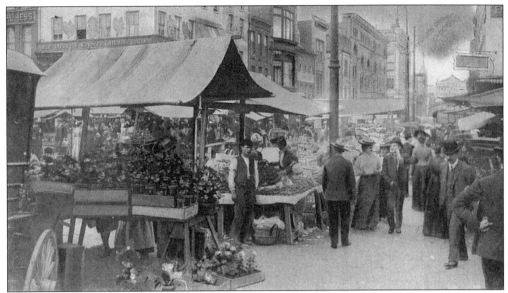

LEXINGTON MARKET. A flower merchant poses in front of his stand.

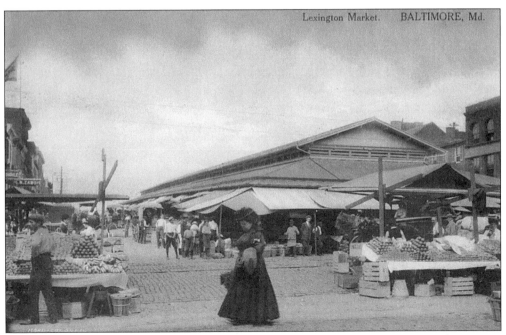

Lexington Market. BALTIMORE, Md.

LEXINGTON MARKET, 1912. Produce stands prosper in front of the marketplace in this view.

73

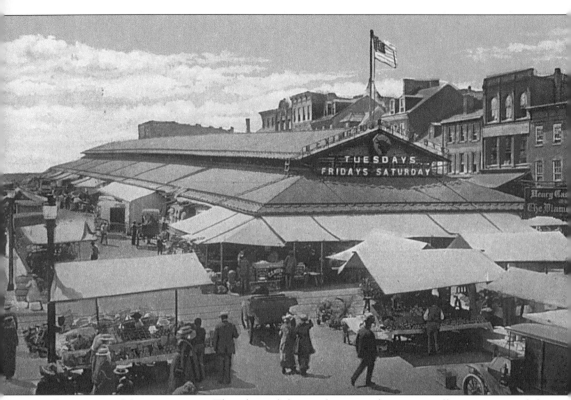

LEXINGTON MARKET, 1920. This shot of the market provides an overall perspective of the city's mainstay.

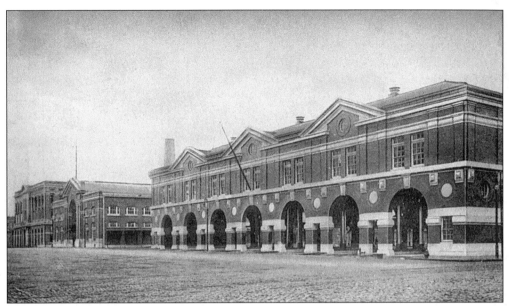

THE CENTER MARKET. With its prime position on the Chesapeake Bay, Baltimore's seafood industry was of utmost importance to the city. The Center Market was a focal point.

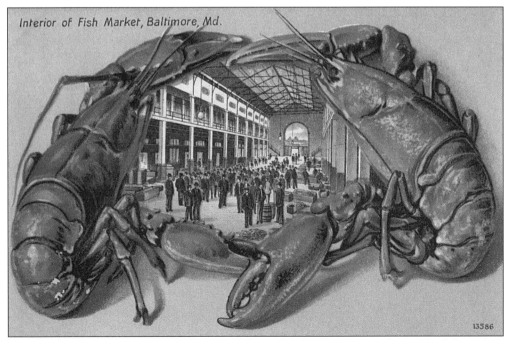

Interior of Fish Market, Baltimore, Md.

13586

FISH MARKET, 1914. Artistic renditions of lobsters border this interior shot of the fish market.

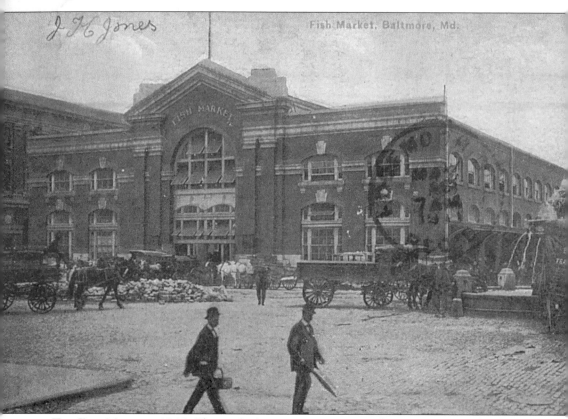

THE FISH MARKET, 1911. The market's massive exterior stands as an impressive landmark.

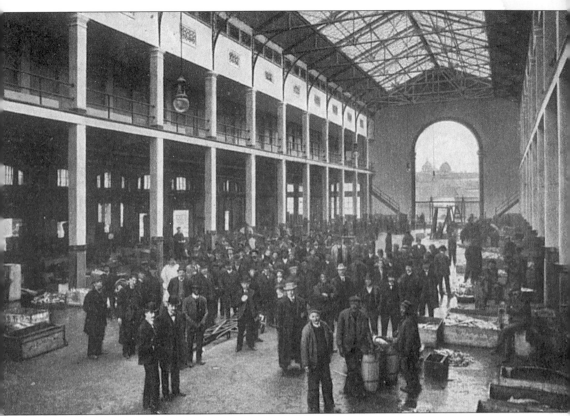

INSIDE THE MARKET. The heavy trade of the sea's delicacies is alive and thriving in this view.

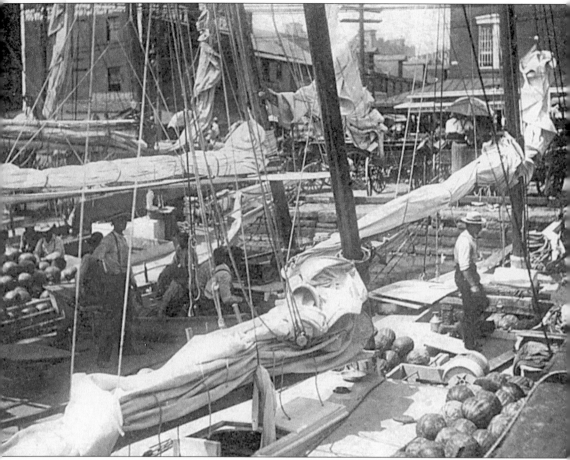

Pratt Street Fruit and Vegetable Wharf. Watermelons overflow from the cargo boats here.

Seven

DOWN BY THE BAY

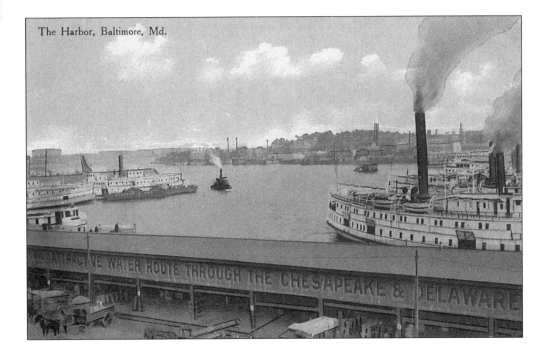

The Harbor, Baltimore, Md.

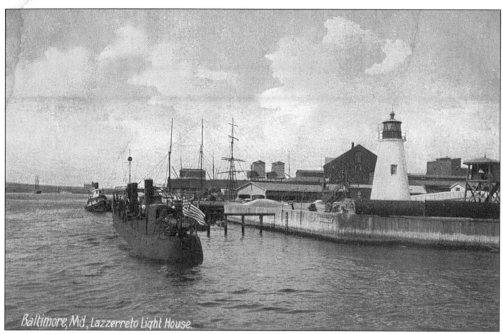

Baltimore, Md., Lazzerreto Light House.

LAZZERRETO LIGHTHOUSE. In Baltimore's busy harbor, this lighthouse beams to aid ships' navigators.

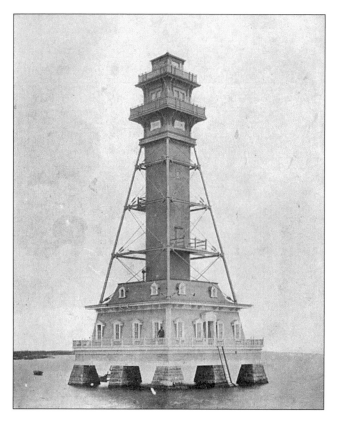

MILLERS ISLAND LIGHTHOUSE, 1911. This lighthouse lit the way through the bay off Bay Shore Park.

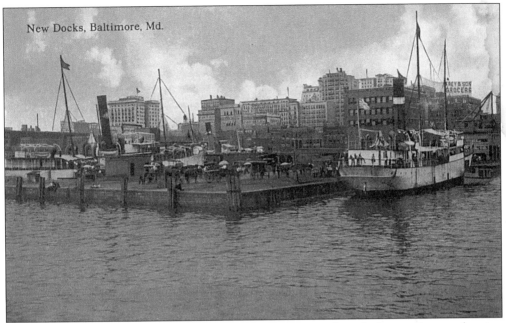

NEW DOCKS, 1914. Filled with wagons awaiting their cargo, these docks were new to the city.

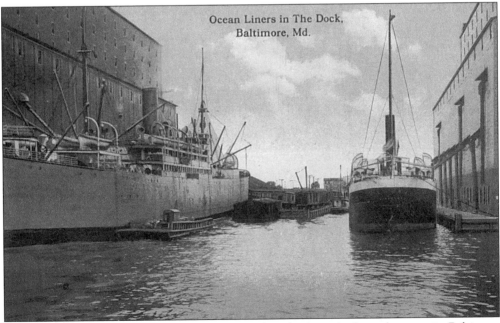

DOCKED OCEAN LINERS. Fruits, vegetables, and seafood aren't the only cargo in Baltimore harbor.

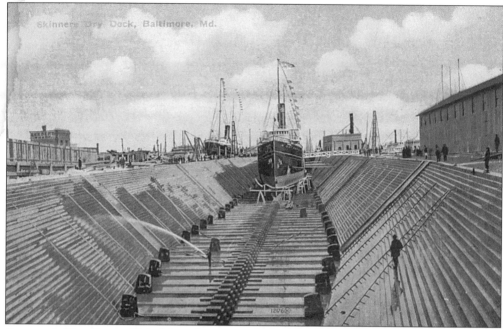

SKINNER'S DRY DOCK. This ship isn't quite ready for launching here.

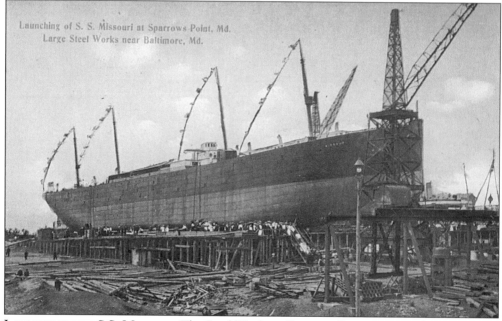

LAUNCHING THE S.S. MISSOURI. The Steel Works at Sparrows Point was an industrial giant.

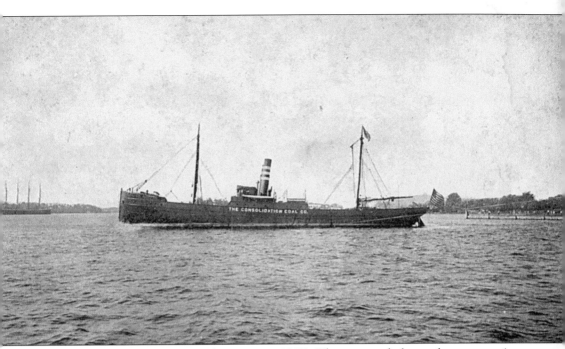

CONSOLIDATION COAL COMPANY FREIGHTER, 1907. This postcard shows the company's freighter afloat in Curtis Bay.

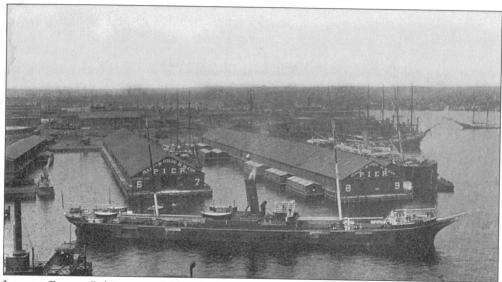

LOCUST POINT. Baltimore and Ohio Railroad Company housed their piers here.

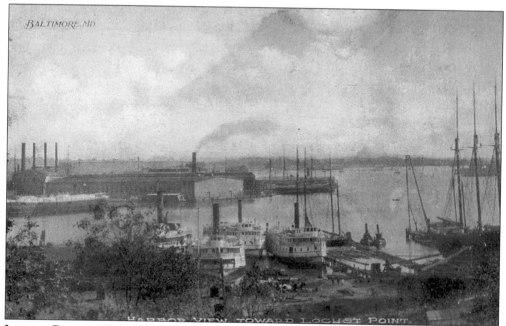

LOCUST POINT, 1908. This view of the harbor shows Locust Point jam-packed with river steamers.

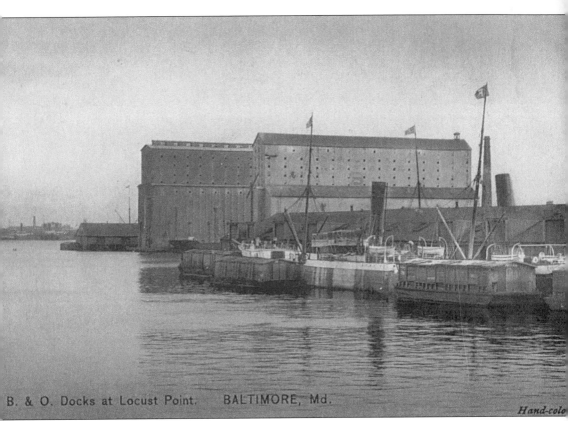

B. & O. Docks at Locust Point. BALTIMORE, Md.

Hand-colo

BOATS AT DOCK IN LOCUST POINT AT THE BALTIMORE AND OHIO RAILROAD PIERS.

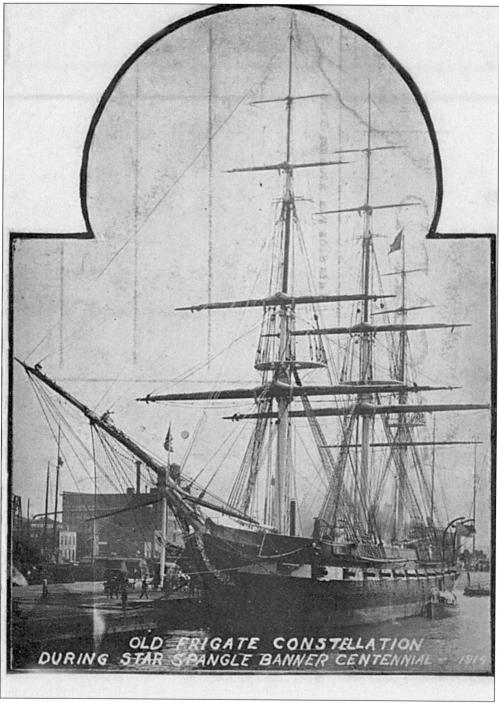

OLD FRIGATE CONSTELLATION
DURING STAR SPANGLE BANNER CENTENNIAL – 1914

THE OLD FRIGATE CONSTELLATION, 1914. Here, she is shown docked during the Star Spangle Banner Centennial.

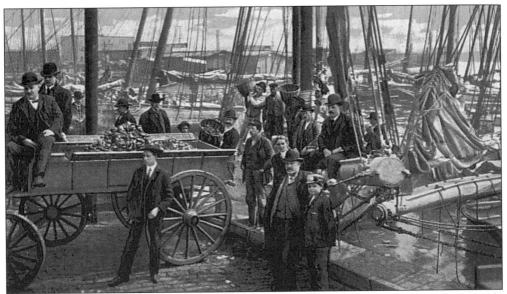

OYSTER LUGGERS UNLOADING. One of the jewels of the Chesapeake Bay would be oysters.

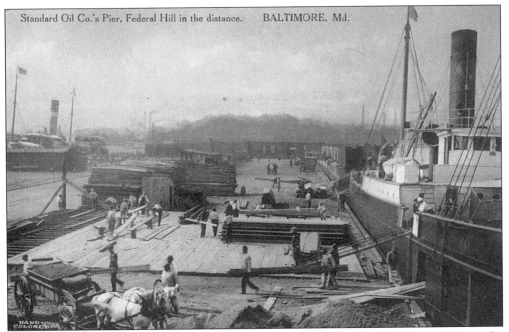

Standard Oil Co.'s Pier, Federal Hill in the distance. BALTIMORE, Md.

STANDARD OIL COMPANY'S PIER, UNDER CONSTRUCTION. Federal Hill is visible in the background.

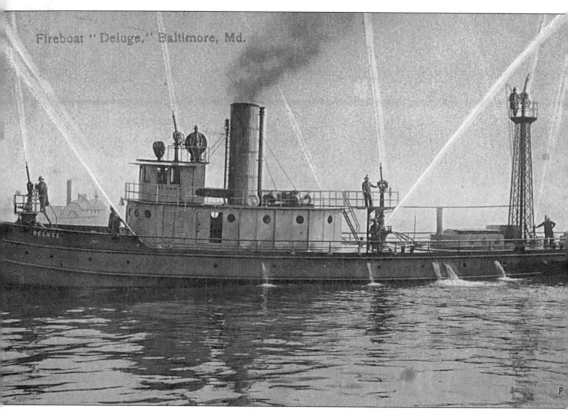

Fireboat "Deluge," Baltimore, Md.

BALTIMORE'S OWN, THE FIREBOAT DELUGE. Here she is showing her abilities by spraying water in all directions.

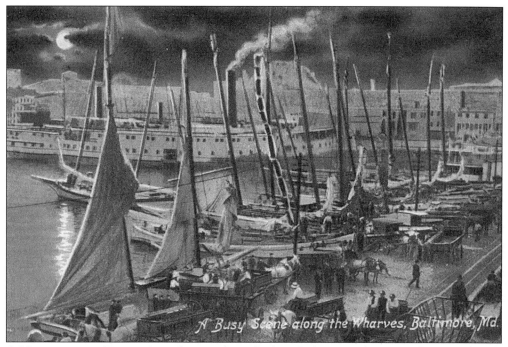

A NIGHT AT THE DOCK. At nighttime along the busy Baltimore wharves, sailboat masts grab most of the attention.

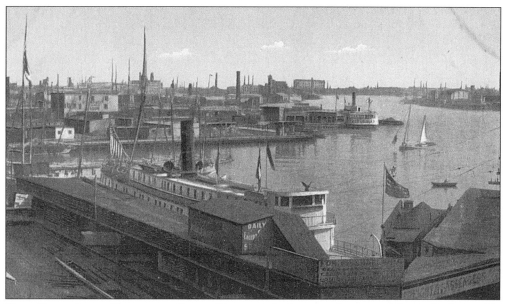

VIEW FROM ABOVE PRATT AND LIGHT STREETS. A photograph taken while perched atop this junction provides an overall view of the basin.

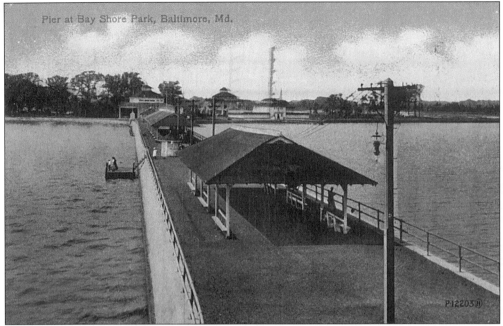

Pier at Bay Shore Park, Baltimore, Md.

P12203H

BALTIMORE POSTCARD, 1914. On the back, P.B.W. claims that, "the bathing here is almost as good as Atlantic City." Almost?

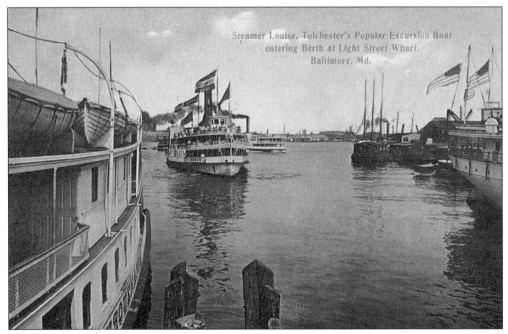

Steamer Louise, Tolchester's Popular Excursion Boat entering Berth at Light Street Wharf, Baltimore, Md.

THE STEAMER LOUISE. Here, she returns to the Light Street Wharf, bringing vacationers back to the big city.

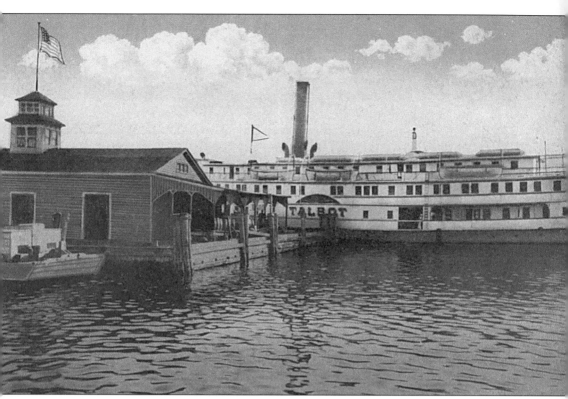

THE STEAMER *TALBOT*. B.C. & A. owned the *Talbot*, which transported voyagers on the longer journey to the Cambridge wharf.

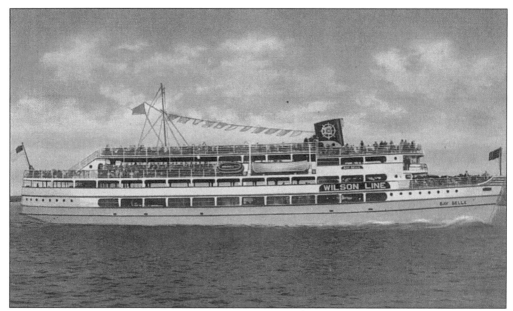

THE S.S. BAY BELLE. This boat offered daily cruises from Baltimore to Betterton Beach.

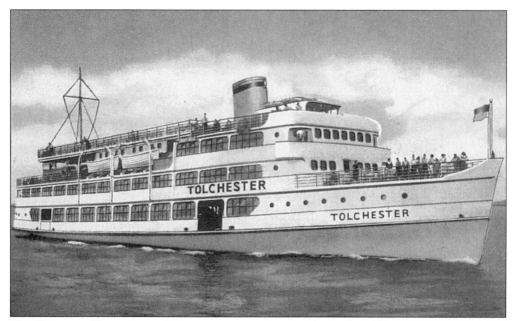

THE STEAMER TOLCHESTER. Excursion steamers ventured into the 1930s.

Eight

OUR SCHOLARS AND HEALERS

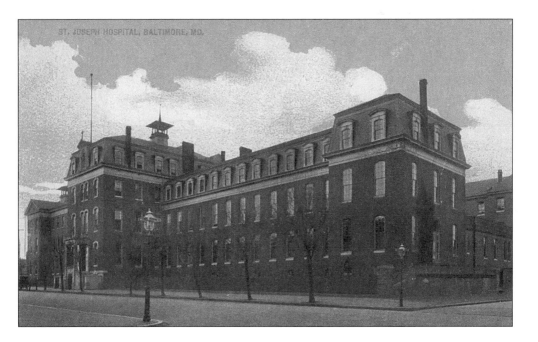

CITY HOSPITAL AND COLLEGE OF PHYSICIANS AND SURGEONS, 1906. Both were institutions of prominence in Baltimore.

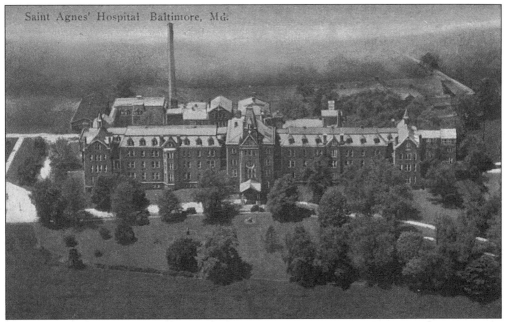

SAINT AGNES HOSPITAL, 1930. It was surrounded by countryside Baltimore at this time.

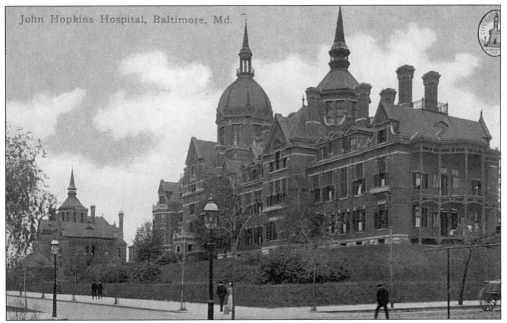

JOHNS HOPKIN'S HOSPITAL. This medical establishment is highly regarded as one of the nation's finest medical care facilities.

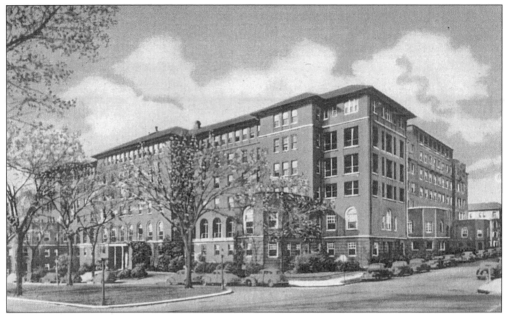

UNION MEMORIAL HOSPITAL, 1940s. The hospital's red brick facade dominates this view.

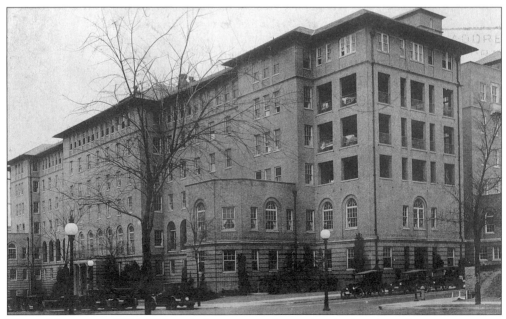

UNION MEMORIAL, 1931. This real photo postcard was taken in the wintertime.

BALTIMORE COLLEGE OF DENTAL SURGERY.
The college was located in town on North
Howard Street.

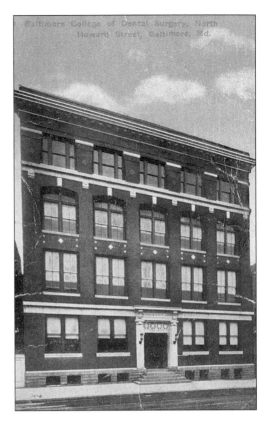

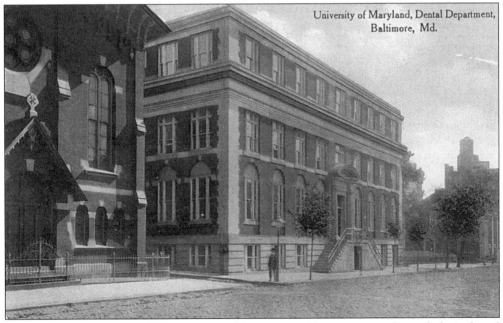

DENTAL DEPARTMENT, UNIVERSITY OF MARYLAND. The university housed their dental
facilities here in downtown Baltimore.

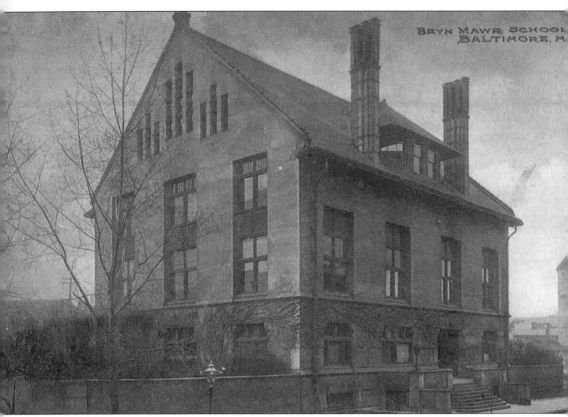

BRYN MAWR SCHOOL. Interesting architecture highlights this 1914 shot.

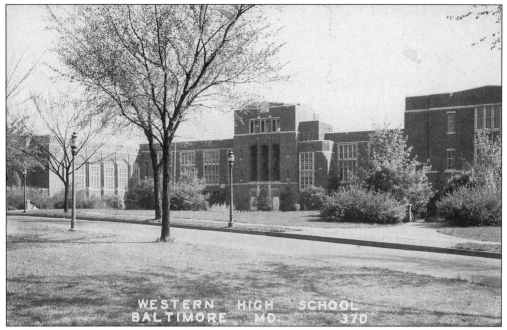

WESTERN HIGH SCHOOL, 1940s.

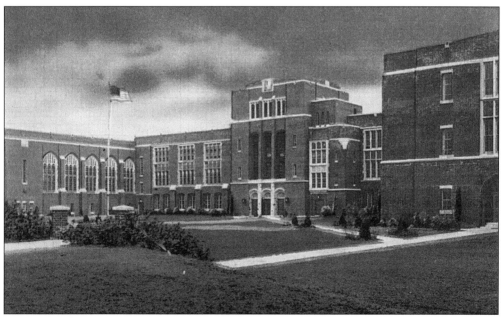

ANOTHER VIEW OF PICTURESQUE WESTERN HIGH.

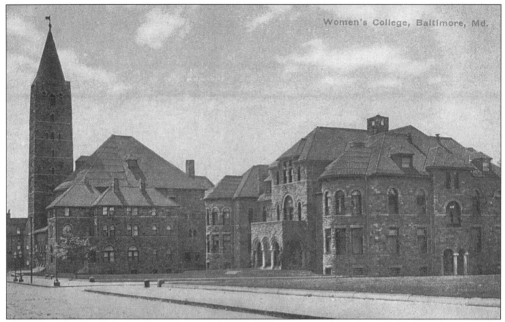

WOMEN'S COLLEGE CAMPUS. Stone walls accented with a red roof accentuate the beauty of the buildings.

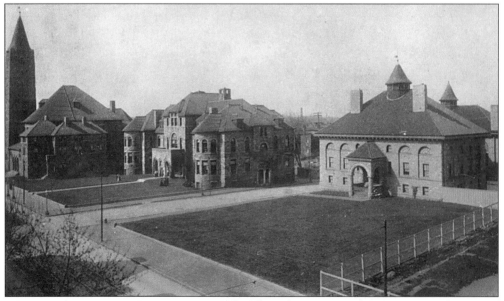

WOMANS COLLEGE OF BALTIMORE, 1907. This photo postcard gives an aerial view of the college.

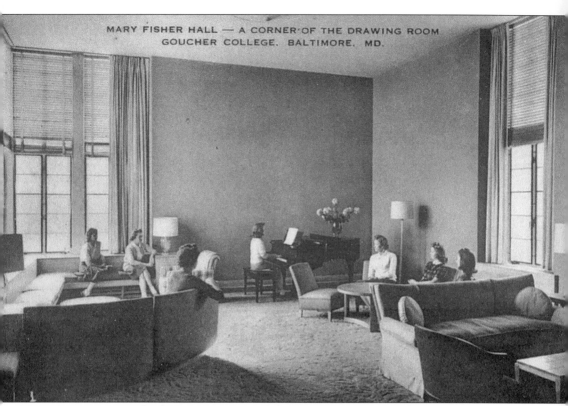

MARY FISHER HALL — A CORNER OF THE DRAWING ROOM
GOUCHER COLLEGE, BALTIMORE, MD.

MARY FISHER HALL. The drawing room provided a retreat at Baltimore's Goucher College.

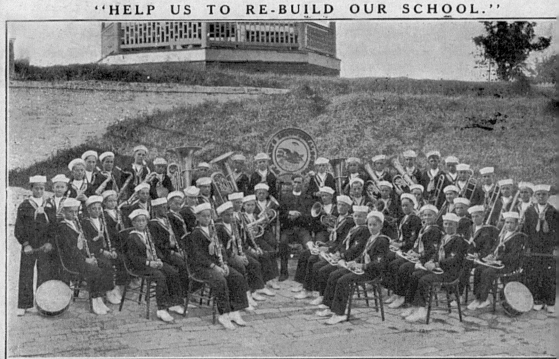

"HELP US TO RE-BUILD OUR SCHOOL."

ST. MARY'S INDUSTRIAL SCHOOL BAND, BALTIMORE, MD.
These 49 boys with their leader, Bro. Simon, played in Cleveland, Detroit, Chicago, St. I
Indianapolis, Baltimore, New York and Philadelphia, September 8 to 30, as "Babe" Ruth's

ST. MARY'S INDUSTRIAL SCHOOL BAND, 1920. After a devastating fire the same year, the school's band raised funds to help rebuild their school. Babe Ruth spent his early years at St. Mary's.

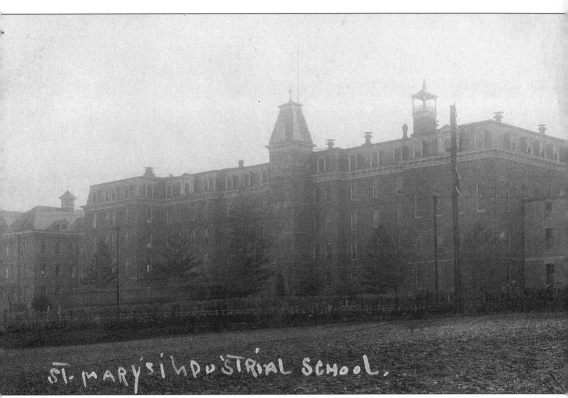

ST. MARY'S INDUSTRIAL SCHOOL. This earlier photo of the school shows how it looked before the devastating fire.

POLYTECHNIC INSTITUTE OF BALTIMORE, 1940. Its overwhelming size is impressive.

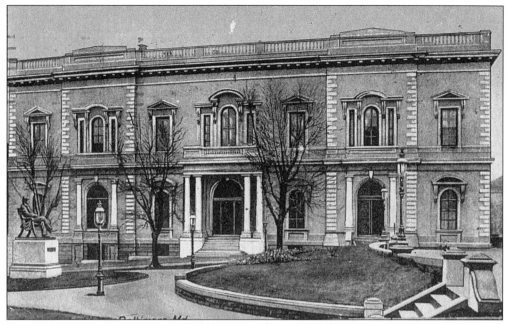

THE PEABODY INSTITUTE OF BALTIMORE. This school has a stellar reputation for its performance arts training.

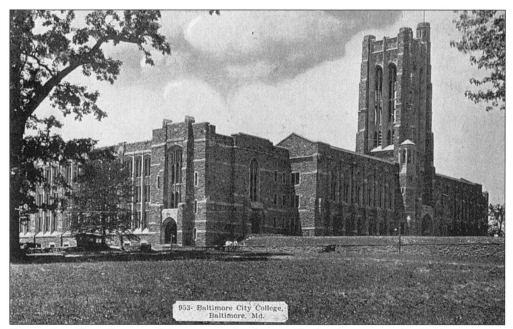

BALTIMORE CITY COLLEGE. This was another home of higher learning in the 1940s.

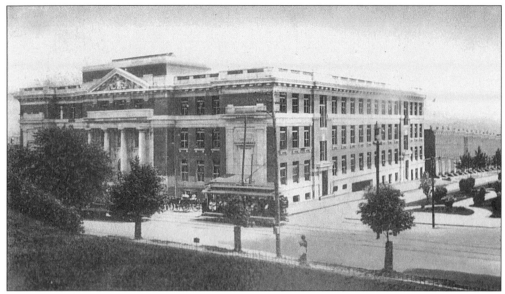

EASTERN HIGH SCHOOL. An overflowing streetcar slows to make a stop for the girls in this 1908 picture.

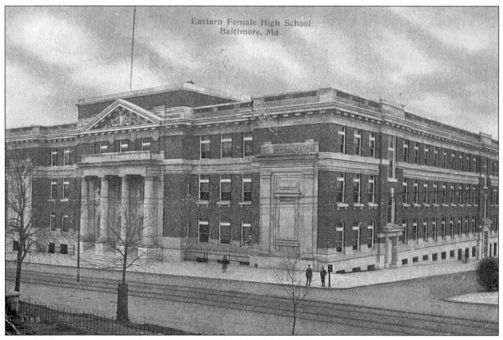

THE EASTERN FEMALE HIGH SCHOOL. This school was located on North Avenue and Broadway.

Nine

WORSHIP AND
CELEBRATION

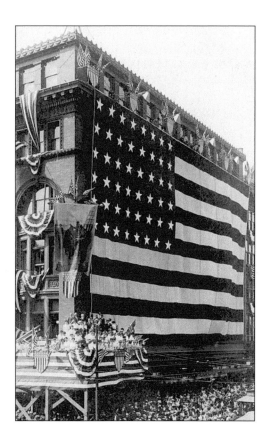

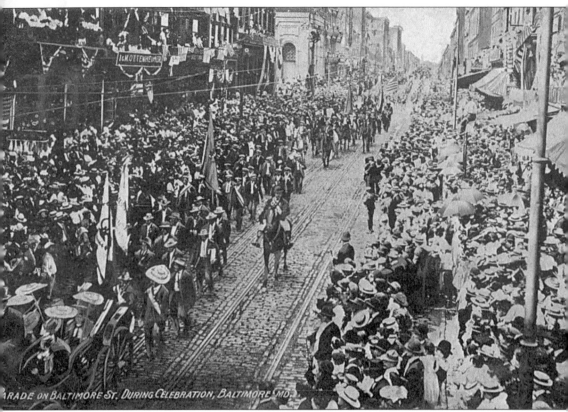

ARADE ON BALTIMORE ST. DURING CELEBRATION, BALTIMORE, MD.

STAR SPANGLED BANNER CELEBRATION. The parade is in full swing as crowds overflow onto Baltimore Street.

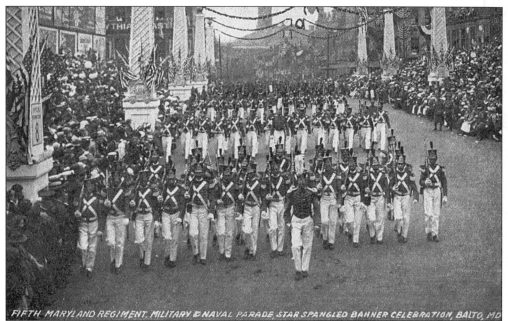

MILITARY NAVAL PARADE. Maryland's Fifth Regiment, Military and Naval Parade march through the celebration.

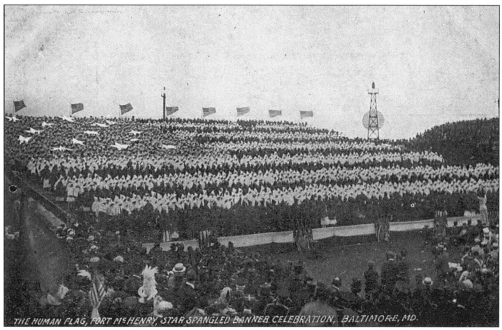

FORT MCHENRY. As the celebration reaches this point, parade members dress to form a human "flag" visible from above.

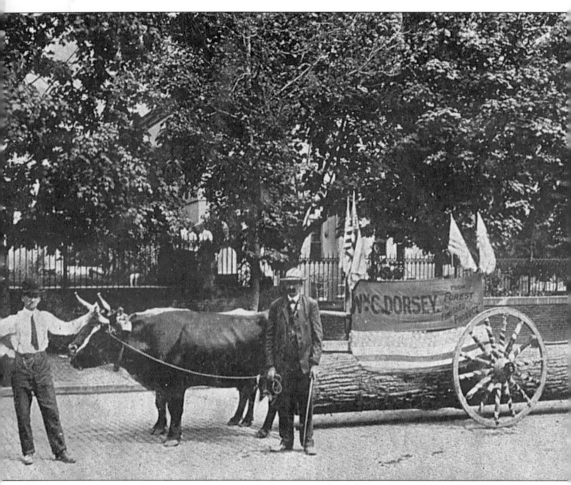

WILLIAM C. DORSEY'S FLOAT. His contribution to the Jubilee highlights his lumber business boasting, "from forest to finished product."

AERIAL VIEW OF A MARCHING BAND.
This shot was taken during the
Fireman's Parade of Baltimore's
1906 Jubilee.

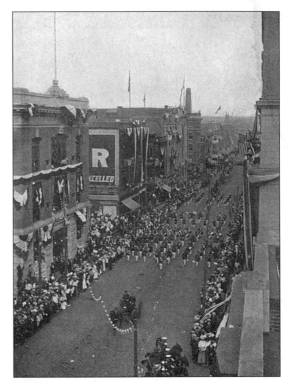

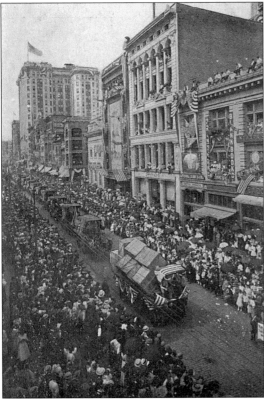

JUBILEE INDUSTRIAL PARADE, 1906.
Onlookers crowd the streets, hang out
shop windows, and lean over rooftops to
secure a better view of the floats.

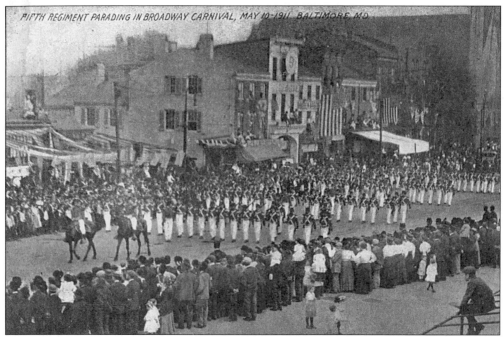

A Crowd at the Broadway Carnival, May 10, 1911. The Fifth Regiment was led by men on horseback.

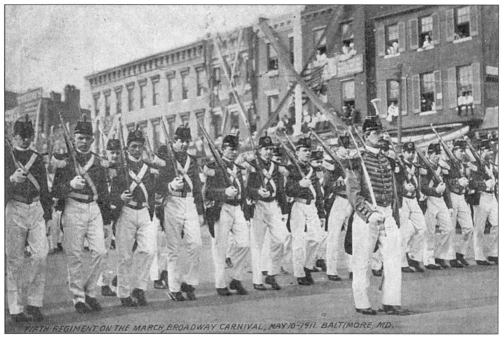

Close-Up of the Fifth Regiment. All decked out, they march in unison.

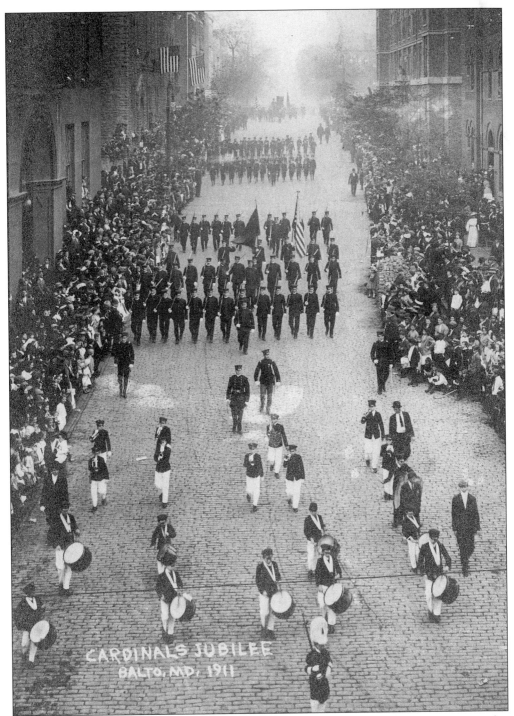

CARDINALS JUBILEE
BALTO, MD, 1911

THE CARDINAL'S JUBILEE, 1911. This real photo postcard shows Baltimore celebrating this annual event.

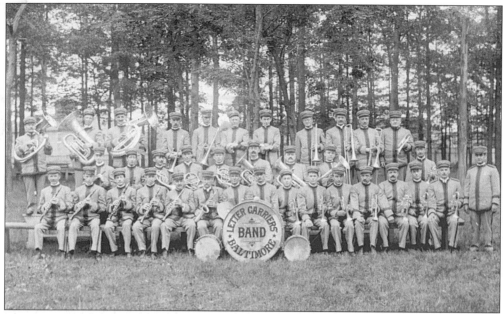

BALTIMORE'S LETTER CARRIERS BAND. Although they aren't marching in stride, this is a great shot.

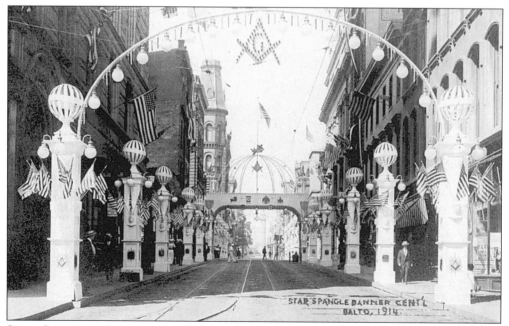

STAR SPANGLED CENTENNIAL, 1914. Baltimore's city streets get all decked out for the celebration; American flags garnish lampposts and archways.

SAINT WILLIAM OF YORK CHURCH, 1940S.

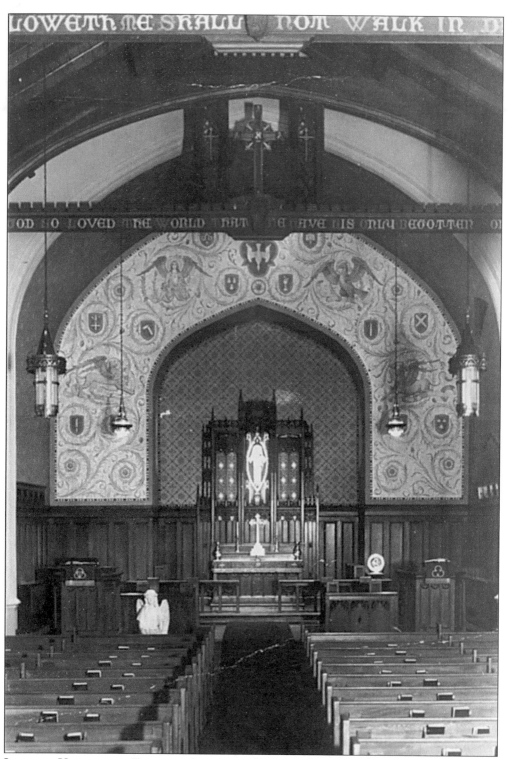

INTERIOR VIEW OF THE EPIPHANY LUTHERAN CHURCH. Pastor Hackmann sent this postcard as a thank-you for an attendee's church offering.

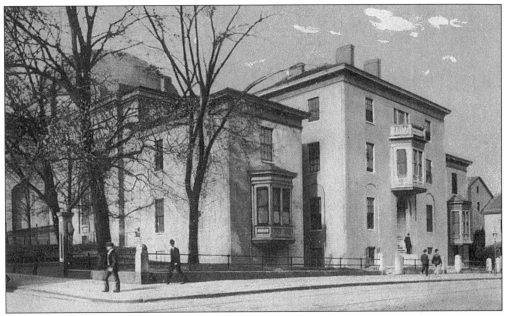

ARCH BISHOP CORRIGAN'S RESIDENCE.

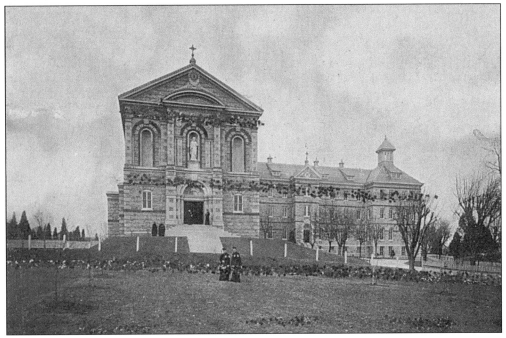

THE MONASTERY ON FREDERICK ROAD, 1906.

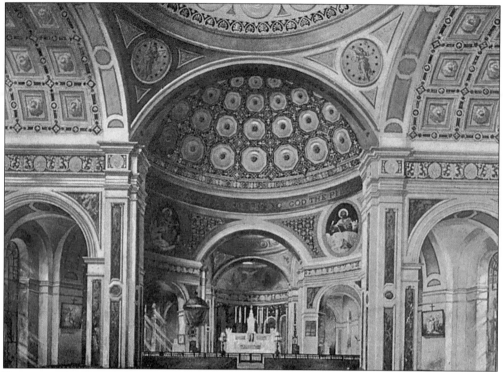

BALTIMORE'S GRAND CATHEDRAL, 1906. This postcard features the new interior of the cathedral.

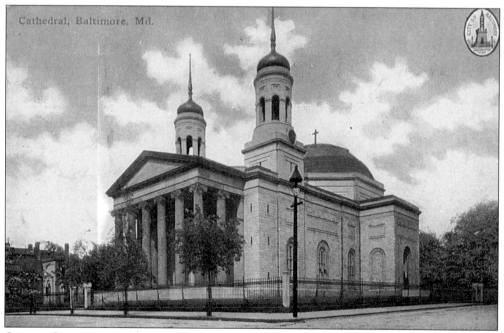

Cathedral, Baltimore, Md.

GRAND CATHEDRAL. Almost as impressive as the stunning interior, this view shows the outside.

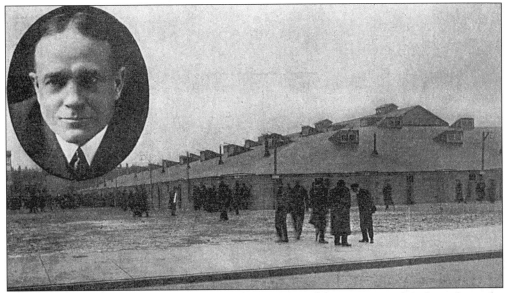

W.A. "Billy" Sunday. W.A. "Billy" Sunday was a well-known evangelist throughout the country. Here we have him and tabernacle in our own Baltimore.

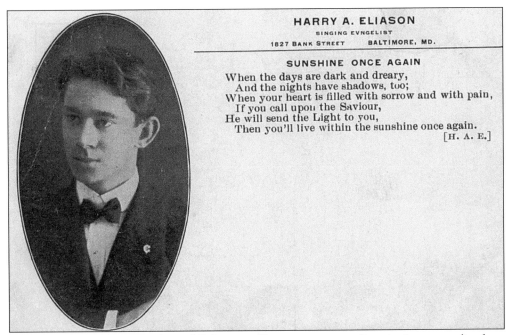

HARRY A. ELIASON
SINGING EVNGELIST
1827 BANK STREET BALTIMORE, MD.

SUNSHINE ONCE AGAIN

When the days are dark and dreary,
 And the nights have shadows, too;
When your heart is filled with sorrow and with pain,
 If you call upon the Saviour,
He will send the Light to you,
 Then you'll live within the sunshine once again.
[H. A. E.]

Harry A. Eliason. A resident of Baltimore, Eliason was a traveling singing evangelist from Bank Street.

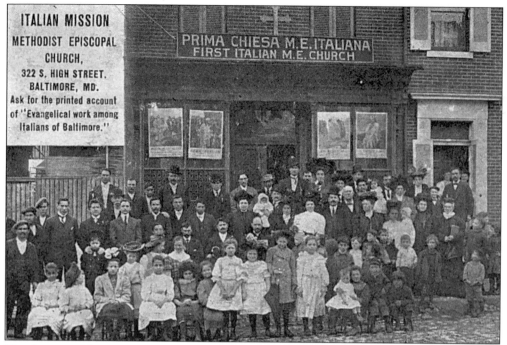

THE ITALIAN MISSION STANDING IN FRONT OF THE FIRST ITALIAN METHODIST EPISCOPAL CHURCH ON HIGH STREET.

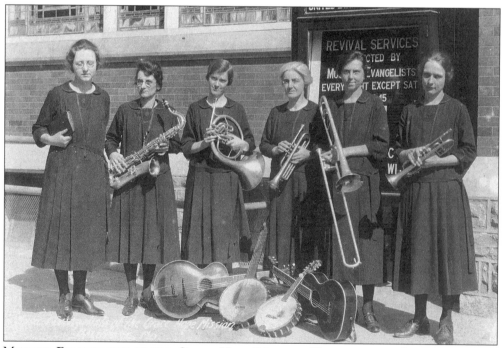

MUSICAL EVANGELISTS OF THE GRACE HOPE MISSION. The six-piece orchestra prepares to perform.

Ten

BALTIMORE'S
GREAT FIRE

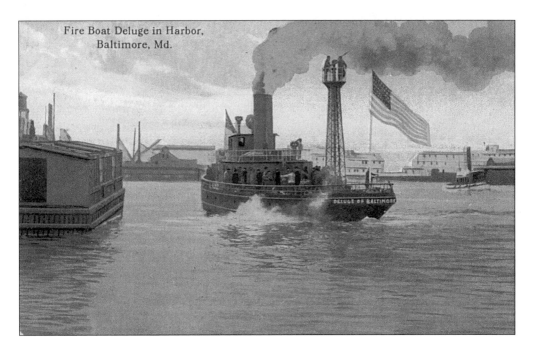

Fire Boat Deluge in Harbor,
Baltimore, Md.

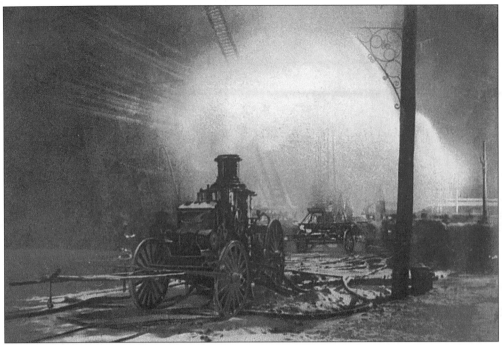

FIREFIGHTERS BATTLE THE GREAT FIRE. In 1904, fire devastated the city. This night view shows the firefighters' futile attempts to thwart the flames.

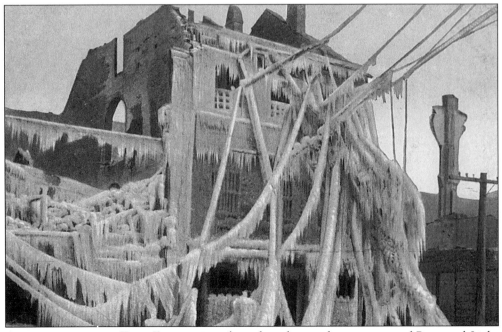

AFTERMATH OF THE FIRE. Frozen wires abound at the northwest corner of Pratt and Light Streets.

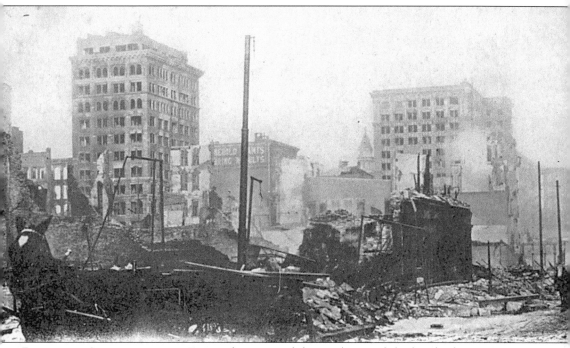

BALTIMORE STREET, LOOKING EAST. This postcard shows what was left after the fire.

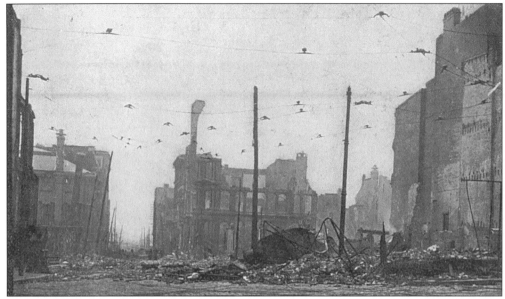

THE SUN AND AMERICAN OFFICES. This is how it looked after the fire.

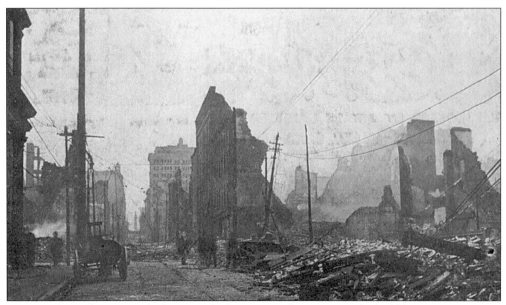

CHARLES STREET. A view looking north shows mound upon mound of rubble.

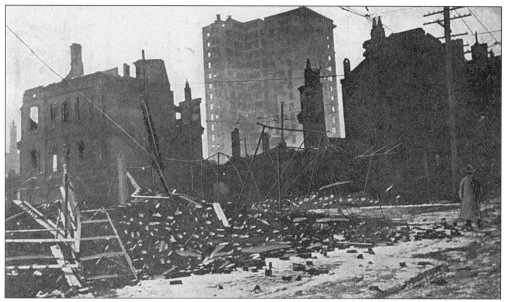

Continental Trust Building. An unsuccessful fireman stands near what is left of the building.

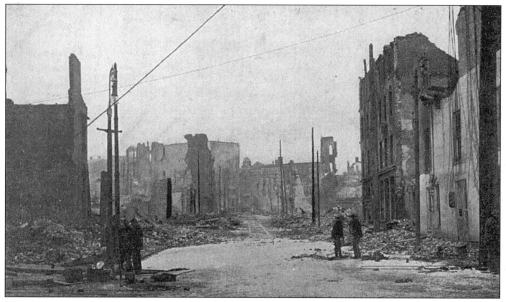

Hanover and Lombard Streets, Looking North.

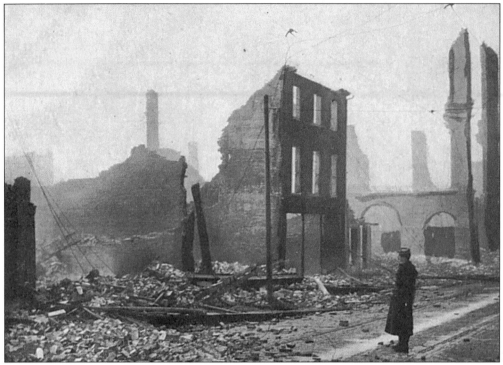

BALTIMORE STREET BRIDGE, LOOKING WEST.

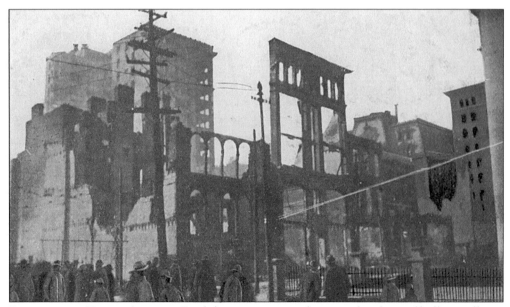

FAYETTE AND NORTH STREETS. Firefighting troops wander around in front of hollow walls.

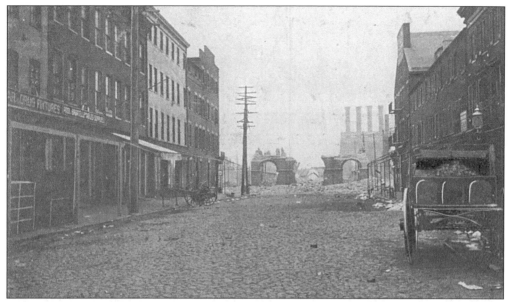

THE MARYLAND INSTITUTE. Luckily, part of this street was spared.

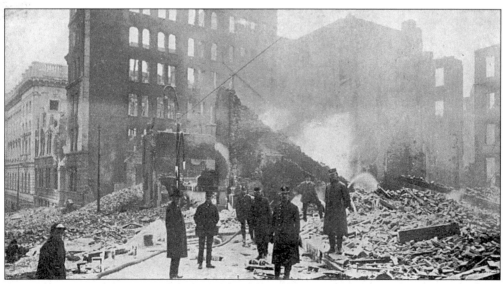

THE RECORD AND HERALD BUILDINGS. The dejected force stands among the ruins of the two buildings.

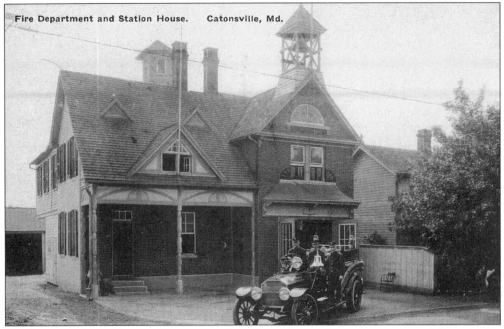

Fire Department and Station House. Catonsville, Md.

CATONSVILLE FIRE TRUCK. This postcard captures the truck on its way out of the suburb's station.

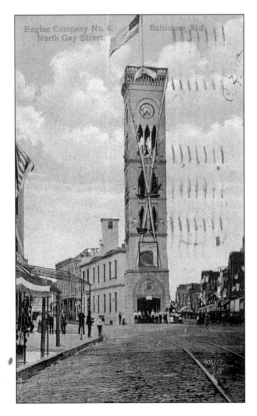

Engine Company No. 6, North Gay Street. Baltimore, Md.

NORTH GAY STREET'S ENGINE COMPANY NO. 6. Hopefully they will never have to fight such a blaze again.